CRUMBLING CASTLES

CRUMBLING CASTLES

The Lost Asylums at Taunton and Northampton

TOM KIRSCH

AMERICA
THROUGH TIME®
ADDING COLOR TO AMERICAN HISTORY

America Through Time is an imprint of Fonthill Media LLC
www.through-time.com
office@through-time.com

Published by Arcadia Publishing by arrangement with Fonthill Media LLC
For all general information, please contact Arcadia Publishing:
Telephone: 843-853-2070
Fax: 843-853-0044
E-mail: sales@arcadiapublishing.com
For customer service and orders:
Toll-Free 1-888-313-2665

www.arcadiapublishing.com

First published 2019

ISBN 978-1-63499-119-3

Typeset in Trade Gothic 10pt on 15pt
Printed and bound in England

CONTENTS

PREFACE

A grid of barred windows towered before me, streaked with decades of rust and neglect. The building was handsomely designed to emanate confidence in curing mental illness, but now that it had been emptied of people, the architecture seemed sinister and imposing. I wondered what stories this shuttered hospital could tell and why it was left to collapse in its slow and deliberate implosion. The ancient building exhaled a breath of musty staleness as I stepped through an open doorway and the long corridors began to echo with the crunching of paint chips and broken glass underfoot. The darkness beyond the threshold enveloped the world of an institution where few have desired to venture. This book brings those glimpses from beyond the shattered window panes and barbed wire fences into the light, while also investigating their amazingly storied past.

The evolution of public mental health care in the United States has been a complex journey, comprised of a tangled web of good intentions and negligence, wealth and deficiency, and the achievements and failures of the constantly evolving field of psychiatry. The revolutionary moral theory movement of the nineteenth century, which advocated care for the mentally ill with compassion and respect, resulted in the construction of some truly remarkable psychiatric hospitals. Their design and operation sought to cure the afflicted using regimen, surveillance and entertainment, contained in a building that was both institutional and graceful. Unfortunately, the highly specialized arrangement of bedrooms, parlors and corridors in these hospitals proved to be rigid and difficult to adapt as these institutions swelled with patients. With little state funding and dismal cure rates, administrators were left with little recourse

other than to abandon the moral theory and provide basic custodial care as beds were crammed into basement, attics and hallways at the turn of the last century.

By the 1950s, most of these buildings would become warehouses for the mentally ill, and with their most chronic wards becoming "snake pits" of degradation, they transformed into the antithesis of their intended purpose. Reforms in legislation and advances in the field of psychiatry in the 1960s prompted drastic changes once again, and a mass exodus began as patients were treated on an outpatient basis or released into nursing homes and community care. Many of the elegant nineteenth-century asylums had become severely outdated, and were simply shuttered and left to rot. After being closed for decades, these structures became veritable museums of psychiatric care, chronicling the attempt to cure insanity with architecture and the ultimate demise of these purpose-built institutions.

This book focuses on the Massachusetts state hospitals established in Taunton, located thirty miles south of Boston, and Northampton, a town in the far western region of the state. Unlike earlier asylums in the region which merely housed the insane, these hospitals were designed using architecture that was believed to help cure mental illness. The accompanying photographs offer a glimpse behind the walls of the institutions and their stunning decay after they were discarded by the Commonwealth.

PRESERVING THE PAST

Although early psychiatric hospitals were designed to cure, they fell short of their ambitions. Under severe overcrowding, most had devolved into places that offered substandard care and some harbored truly atrocious conditions. Accounts of confinement, trauma and abuse inside these facilities reveal the dark times in the country's history of mental health towards the middle of the twentieth century.

Unlike old banks and department stores, these buildings have an emotionally charged past, and the stigma surrounding mental health has helped pushed these institutional buildings to be ignored by legislators, developers and the general public. Some former patients have understandably expressed a sense of relief when bulldozers finally began to chew away at the brick and stone. To raze or redevelop them without remembrance, however, is to foolishly sanitize our past. Almost all of the 19th century asylums built in Massachusetts have either vanished into obscurity by their demolition, or had their histories white-washed to become more palatable for tenants during their remediation. This book strives to retain a memento of the hospitals which have been deemed too costly or degraded to save in their entirety, and chronicle their last moments before being destroyed or redeveloped into a hollow ghost of their former selves.

A NOTE ON NEGATIVITY

It's tempting to focus on the negative aspects of psychiatric hospitals, as many people witness their history solely through exposés in the media and scenes played out in novels and movies (some are authentic, but many are also purely sensational). Photographs of these buildings in a derelict state can lead the imagination to even darker places. It's important to remember that although there were some awful conditions, the hospitals were in much better physical shape when they were in operation. The treatments, though seemingly barbaric by modern standards, were designed to help, and in some cases save lives. Finally, despite a few exceptions, mental health workers did care very deeply for their patients and were devoted to making their lives as best as they could in an extremely difficult environment. The benevolence and determinism of the staff in both the mental health and developmental disability fields deserves commendation far above and beyond what is typically given, as they are often the scapegoat of critics who have not considered the bureaucratic and systemic failures which led to the degradation of the state hospital system in the twentieth century.[1]

TERMINOLOGY

Just as the treatments and methods of psychiatry have drastically changed over time, so has the language. Words that may seem insensitive and hurtful in modern times were accepted terminology in the medical field, such as "insane," "lunatic" and "asylum." Residents of these facilities were often called "patients" and even "inmates" without negative connotation. The names of the institutions themselves have gone through multiple iterations to reflect the changing attitudes and lessen the stigma surrounding them; the "lunatic hospitals" became "insane asylums," "state hospitals," and finally "psychiatric centers." The usage of antiquated words in this book is not intended to be derogatory, nor a justification of these terms. Instead, they are used to provide a historical and cultural context to the reader, which would not be possible using their modern equivalent.

INTRODUCTION—A MASTER PLAN

To be considered "insane" in early America had particularly dire consequences; many of those with psychiatric illness, epilepsy, or a developmental disability were kept locked in basement rooms and shackled to furniture. They were often thought of as sub-human, and were whipped or beaten into submission, even by their own families.[1] Those who left the confines of their homes were committed to public almshouses or prisons, where they were similarly taken advantage of. Reformers like Benjamin Rush (1745-1813) and the Quaker society pioneered a movement in America that would become known as "moral treatment," which attempted to cure insanity with kindness and compassion rather than with whips and chains. This monumental step forward in mental health was adopted quickly, and in 1833 the state of Massachusetts established its first publicly funded asylum for the insane in Worcester.

The managers at the Worcester Lunatic Asylum did their best to treat patients with dignity and respect; however, curing insanity proved to be more difficult than anticipated. The people that emerged from the basement dungeons of the countryside had very serious disorders, and tended to become long-term residents.[3] When the hospital ran out of beds, people who were deemed incurable, or "chronic," were sent back to their dank confinements or turned loose to aimlessly wander the country roads.

Dorothea Dix (1802-1887), an activist who championed to treat the insane with compassion, tracked these ex-patients of the Worcester hospital back to the prisons and houses where they were returned and was horrified at what she saw. Many

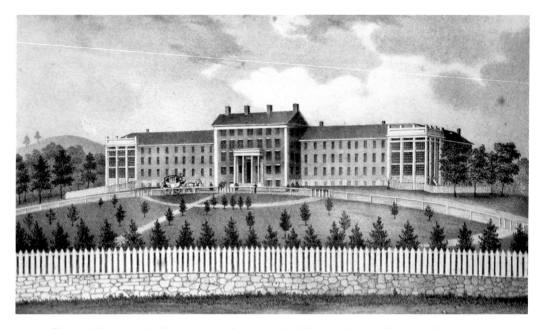

The state's first asylum in Worcester was a Colonial-style building that formed a U-shape, which created a protected courtyard for supervised outdoor activities. Although the hospital's mission was highly regarded, the building itself was lamented for its shoddy construction.[2] [U.S. National Library of Medicine]

resided in cages or locked rooms, sleeping on a bed of straw and covered in their own filth. Some were even forced to work as slaves. Her shocking testimony was described in a memorial to the State Legislature in 1843, with an earnest request for the construction of a new asylum in Massachusetts for the state's indigent:

> I shall be obliged to speak with great plainness, and to reveal many things revolting to the taste, and from which my woman's nature shrinks with peculiar sensitiveness. But truth is the highest consideration. I tell what I have seen—painful and shocking as the details often are—that from them you may feel more deeply the imperative obligation which lies upon you to prevent the possibility of a repetition or continuance of such outrages upon humanity. If I inflict pain upon you, and move you to horror, it is to acquaint you with suffering which you have the power to alleviate, and make you hasten to the relief of the victims of legalized barbarity.[4]

The Commonwealth answered Dix's plea by establishing new state hospitals that used a revolutionary design: the linear plan. It was devised by Dr. Thomas Story Kirkbride (1809-1855), a renowned physician and founding member of the Association of Medical Superintendents of American Institutions for the Insane (a

precursor to today's American Psychiatric Association). With the assistance of medical colleagues and architects, he established guidelines of asylum construction based on moral treatment and the belief that a person's environment shaped their behavior, a principle known as environmental determinism. Physicians of the time had known that stuffy, cramped quarters harbored filth and disease, and when combined with the stresses of urban life or physical abuse, they believed this to cause insanity. To counteract these dangers, Kirkbride envisioned a handsome building that would be specially designed to cure mental illness and return its patients to society. This would be possible by instituting a daily regimen of healthy food and prayer, careful surveillance to prevent abuse and creating a calm and wholesome environment, away from the evils of city life.

The layout of Kirkbide's ideal hospital consisted of a large singular building, arranged in a stepped-wing configuration. Stemming from the central administration block, each wing contained sections, or wards, in an echelon formation. This allowed fresh air to move through both ends of the corridors, removing any disease-causing germs that were thought to exacerbate insanity. A south-facing position of the building, combined with large windows and high ceilings, would create a bright

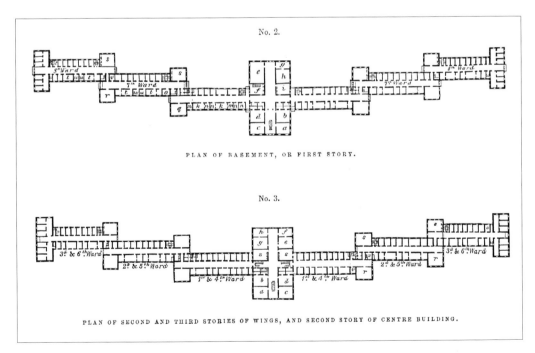

No. 2.

PLAN OF BASEMENT, OR FIRST STORY.

No. 3.

PLAN OF SECOND AND THIRD STORIES OF WINGS, AND SECOND STORY OF CENTRE BUILDING.

The linear floor plan of Kirkbride's model hospital, as illustrated in his book *On the Construction, Organization, and General Arrangements of Hospitals for the Insane.* [U.S. National Library of Medicine]

and cheerful atmosphere, with nothing to remind patients of their former gloomy dungeons. The single hallway was essential for surveillance; here, the attendants and nurses could keep an eye on all their patients and the doctors would ensure there was no abuse taking place.

Kirkbride's design was embraced by Dix and those on the board at the AMSAII, whose members greatly influenced legislators seeking to build public insane hospitals. As a result, a multitude of institutions following the linear plan (later known as the Kirkbride plan) were constructed across the country. Massachusetts would eventually build four of these prolific asylums, with each becoming increasingly larger and more elaborate to reflect the growing number of patients and changing trends in psychiatry. The earliest of these hospitals in Taunton and Northampton introduced revolutionary ways to treat the mentally ill in the state, but their mission of curative treatment would be overshadowed in short time.

TAUNTON STATE HOSPITAL— SILVER CITY'S SECRET

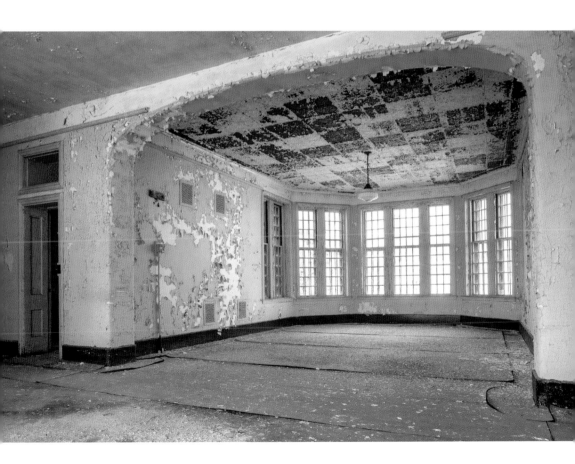

There is a strange place in Taunton where a formidable fence stands alone in a meadow. Like a misplaced modern sculpture, its carbon-black steel contrasts starkly with the surrounding oak and maple trees which line a gentle stream. The heavy links are woven so close together that one can hardly see through them, and the top of the structure curls towards you like a cresting metallic wave. These elements have all been designed for one purpose: to keep people out. Beyond the seemingly-impenetrable wall, in the forbidden zone, lies only a field of grass. It's almost difficult to believe that this forlorn patch of weeds was once the site of the original Taunton State Hospital, Massachusetts's first linear plan asylum built under Kirkbride's moralist principles. Long before its condemnation and imprisonment behind the barrier, it was something to be admired.

When the Commonwealth announced its intent to build a new state hospital for the insane in 1851, towns clamored to become its destination. This seems unusual in modern times, but back then it would bring not only the opportunity of permanent jobs to a small town, but also the prestige of being home to a modern medical facility. The residents of Taunton managed to pool together $13,000 as a gift to the commissioners to purchase a nearby farm and won the honor of hosting the new asylum.[1] Situated atop a hill, the site included a quiet patch of woods, farmland and a scenic river to soothe disturbed minds.

The new public hospital brought the hope of curing insanity to those who could not afford care at a private asylum, and it was decided by the trustees that the architecture would incorporate principles of the moral theory. Designed by architect Elbridge Boyden (1810-1898), the Renaissance Revival-style building followed Kirkbride's linear arrangement of rooms. A central administration block held offices and apartments for the superintendent and two crooked wings stretched out on either side. An additional wing extended from the center towards the back, which contained core services such as the kitchen, laundry and chapel. This wing also blocked sight and sound between the male and female patients housed in either side of the building, as fraternization between genders was to be avoided. Cast iron capitals and ornate cupolas provided enough décor to be considered handsome, but not overly pretentious. The crown jewel of Boyden's work was a majestic center dome, rising seventy feet from the roof and providing panoramic views of country life in Bristol County.[2]

When the hospital was built, doctors believed that exhalations from people polluted the air, caused disease and thus exacerbated mental illness.[3] In order to remove this miasma of contagion from the patients at Taunton, an elaborate ventilation system was integrated into the architecture. The ornamental cupolas on the roof were actually ventilation towers, connected to flues in the hospital's heating system. Fresh air was brought into the basement through giant fans and pushed out these towers to remove the vitiated breath and foul odors of the hospital which bred disease.

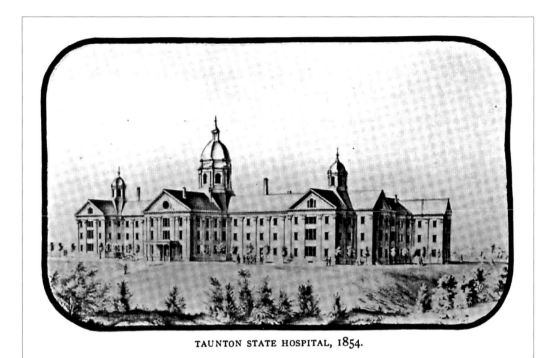

TAUNTON STATE HOSPITAL, 1854.

An early drawing of the original hospital building. [Asylum Projects]

As advised by Kirkbride, sections of each wing were divided into isolated wards where patients were classified by severity of their illness. There were "front wards" for new admissions and acute patients who had an optimal prognosis, and "back wards" for the elderly, infirm and most serious cases. The most unruly and violent patients were sequestered at the ends of the wings, away from those who had better chances of recovering. At Taunton, verandas secured by cage-like iron bars were installed at the wing tips, giving these high-risk patients the ability to exercise in the open air without leaving the institution.[4] The grounds were beautifully landscaped with trees and gardens for both patients and visitors to admire and enjoy, and even included a golf course for entertainment. Built at a cost of $151,752, the facility opened as the State Lunatic Hospital at Taunton on April 7, 1854.[5]

The building was designed for the accommodation of 250 patients, but with many streaming in from the crowded hospital in Worcester, Taunton would be filled to ninety-two percent of its capacity by the end of its first year alone. As the hospital exceeded its limits, administrators began placing beds in the airy sitting parlors and corridors that Kirkbride had so carefully designed for ample space and ventilation.

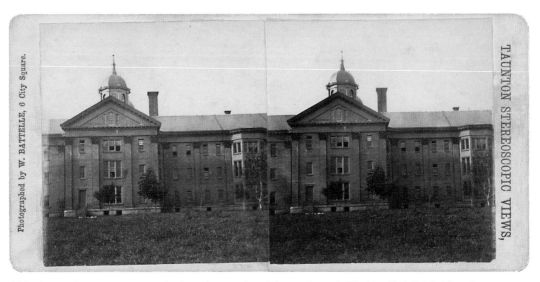

This nineteenth-century stereoscopic photo shows a view of the men's ward. [The New York Public Library]

G 21957 The Drive, State Lunatic Asylum, Taunton, Mass.

View of the approach to the hospital and its park-like grounds, *circa* 1908. [Author's collection]

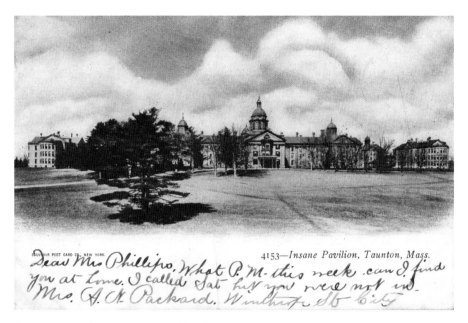

4153—*Insane Pavilion, Taunton, Mass.*

Dear Mrs. Phillips, What P. M. this week can I find you at home. I called Sat but you were not in. Mrs. A. N. Packard. Winthrop St. City

Photo postcard of the hospital *circa* 1910, after several additions were made. [Author's collection]

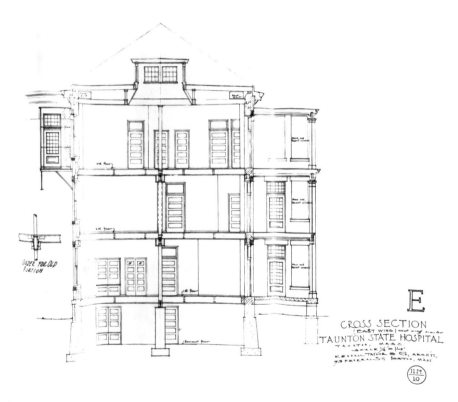

E

CROSS SECTION
(EAST WING) and very similar
TAUNTON STATE HOSPITAL
TAUNTON, MASS.
SCALE ¼"=1'-0"
KENDALL, TAYLOR & CO., ARCH'TS,
73 FEDERAL ST., BOSTON, MASS.

Cross section of a wing and screened-in porches, used in renovations of the hospital around the turn of the century. [Massachusetts State Archives]

By 1860, there was an impetus to find a solution for the growing number of chronic patients—those deemed "incurable" by doctors—who would languish in the back wards of the hospital for years or even the rest of their lives.

In 1873, two three-story wings were added to the ends of the building, providing an additional 180 beds. The hospital's superintendent remarked on the expansive size of the building in his report that year: "To you, who visit the wards, it may be interesting to know that an inspection, by merely looking into the door of each room, necessitates a walk of considerably more than a mile."[6] The extended space was still inadequate however, for the hospital's door was open to anyone who fell under the broad category of insanity. Admissions from this period show that causes for mental illness could stem from sunstroke, masturbation, religious excitement, reading and even the bite of a cat.[7]

A much-needed infirmary for women was added to the end of the building in 1891. An identical one for men was built a year later at the opposite end, keeping the layout symmetrical. Known as the Brown and Howland Infirmaries, these structures featured octagon-shaped turrets and curved breezeway passages, used to improve airflow and isolate contagious patients. Despite these additions, the hospital was still plagued by overcrowding. A large expansion to the hospital took place in 1934 by the Public Works Administration Project, creating a group of buildings which included a new infirmary, medical building and nurse's home.

Despite the hospital's mission to cure insanity and release people back into society, many spent the remainder of their lives behind the asylum's walls. Among them would be Thomas Hubbard Sumner (1807-1876), a seasoned sailor who discovered the line of position used in celestial navigation, which would become known as the "Sumner Line." His innovative technique had saved countless lives at sea, as sailors could now pinpoint their location with extreme accuracy. His monumental achievement was overshadowed by his degrading mental health in his later years, however. After spending some time in the McLean Asylum, he was committed to Taunton in 1865 (on his birthday, no less) as "hopelessly deranged."[8] Despite his success and notoriety, he died alone at the hospital and no obituary was written, nor any memorial service performed.[9]

Another patient, though rather infamous, was Jane Toppan (1854-1938), a serial killer who was arrested for murder in 1901. Her pleasant attitude had given her the nickname "Jolly Jane," but during her tenure as a nurse at Boston hospitals, she developed a secret morbid fascination with autopsies and would discretely poison her patients using cocktails of morphine and atropine. Lying next to her victims as they neared death, she would attempt to see the inner workings of their souls through their eyes.[10] After confessing to the murder of thirty-one people, she was

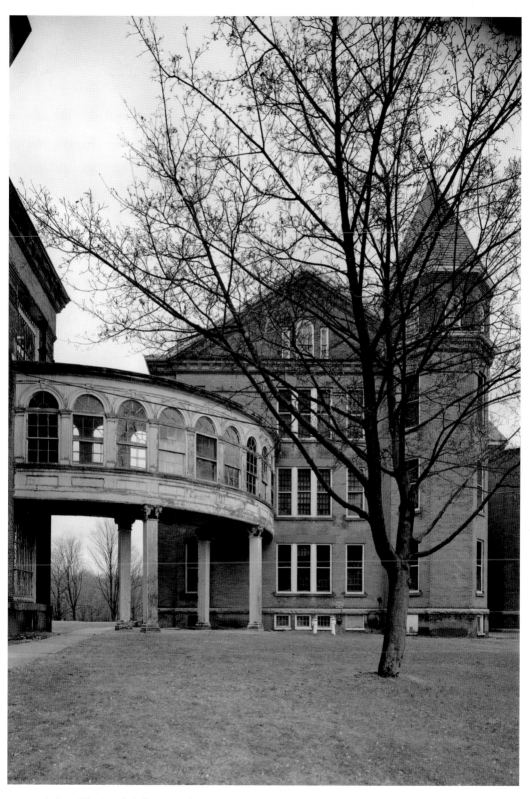

A view of the female infirmary and connecting breezeway in 1987. [Library of Congress]

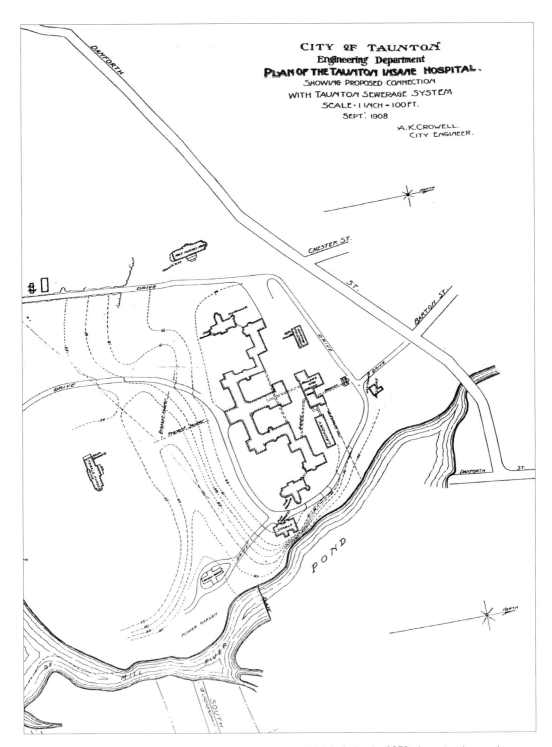

This 1908 map illustrates the expansive footprint of the hospital, which includes the 1873 wing extensions and 1890s infirmaries. [Massachusetts State Archives]

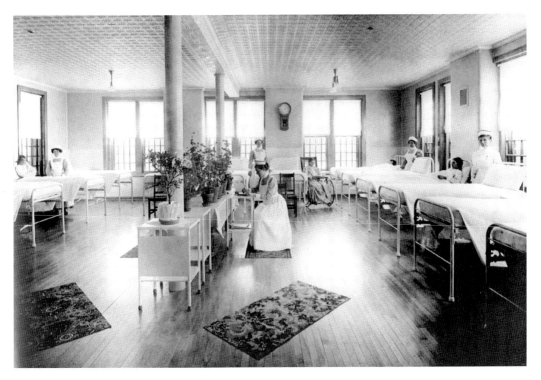

This undated photo offers a glimpse inside one of the hospital's wards for female patients. [*Taunton Daily Gazette*]

committed to Taunton where she developed a paranoia of being poisoned and nearly starved herself to death by refusing her meals.[11] After recovering, she spent the remaining thirty-six years of her life confined at the hospital.

In 1951, Taunton State Hospital reached its pinnacle of overcrowding, as it held 2,356 patients in a facility only meant for 1,510.[12] This would all change quite rapidly in the 1960s though, as new legislation and drug therapy allowed patients to be treated outside the hospital and the population at Taunton began to plummet. In August of 1972, the aging Kirkbride complex was considered unsafe by the Department of Public Safety and was condemned, with services relocated to newer buildings on the campus.[13]

Situated behind the hospital's perimeter wall and located on restricted property, the crumbling gem was known by few. Because of vigilant security patrols and barriers such as the massive anti-climb fence erected by the state, the historic building was protected by thieves and remained incredibly intact in this regard; however, without any upkeep, the weather and elements gradually made their way into the structure.

The term "demolition by neglect" was exemplified best in 1999 when the beautiful dome that adorned the administration block spectacularly collapsed into the

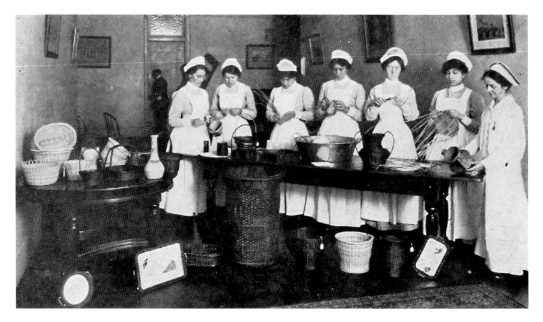

Here, aides at Taunton are taught how to run an occupational therapy class in basket weaving, *circa* 1919. [National Library of Medicine]

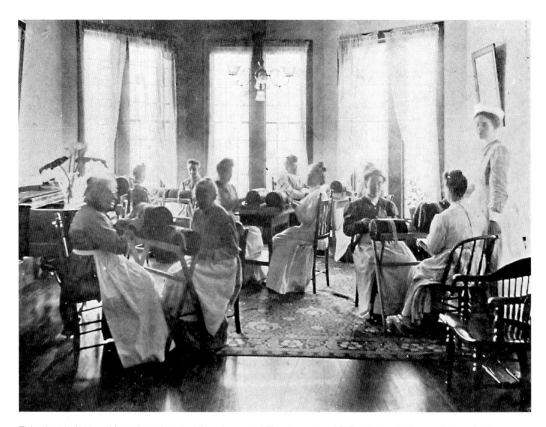

This class in lace-making takes place in a female ward at Taunton, *circa* 1919. [National Library of Medicine]

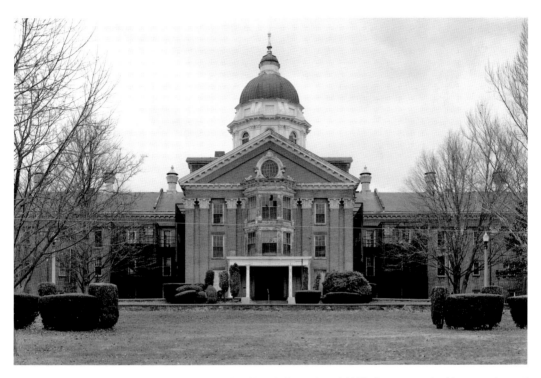

The main entrance of the original hospital building in December of 1987; the structure had been condemned for twelve years and started to show signs of deterioration. [Library of Congress]

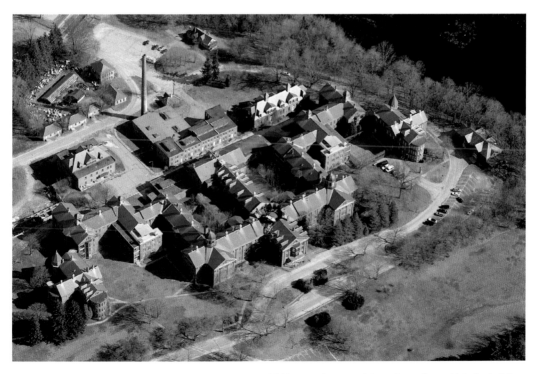

An aerial view of the Kirkbride structure in the early 2000s; note the central dome has collapsed into the building. [Pictometery/Bing Maps]

building due to lack of maintenance. After a major fire gutted what remained of the administration block in 2006, the building was slated for demolition despite the viability of both wings, its uniqueness as being the first Kirkbride building built in Massachusetts and its listing on the National Register of Historic Places.

In 2009, the nineteenth-century fixtures and materials were stripped out and sold by a salvage company. Over 50,000 tons of the stout brick walls were crushed into backfill as the hospital crumbled under the wrecking machinery.[14] At the time of this writing, Taunton State Hospital still operates as a psychiatric hospital in other buildings on campus, though no vestige of this monumental structure remains. There is only the massive anti-climb fence, which now pointlessly surrounds an empty grass lot.

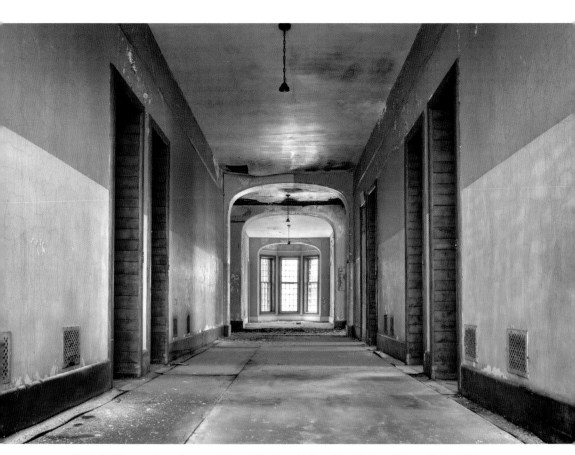

The tall ceilings and spacious corridors of this long-shuttered hospital created a cathedral of decay.

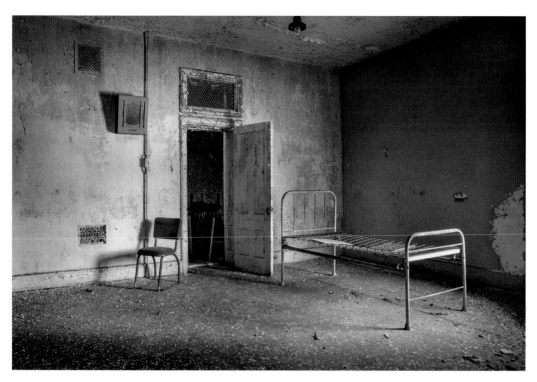

The building was emptied of usable items and furniture, but many rooms still held relics from the past, left undisturbed for decades.

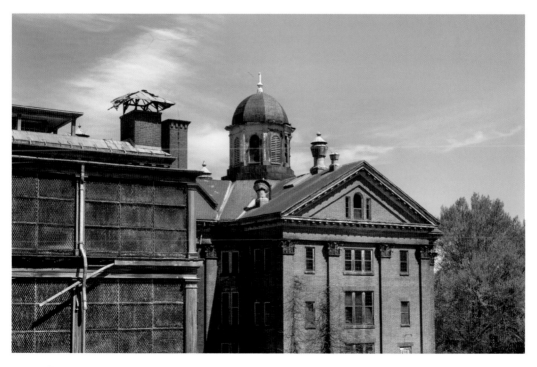

This view shows the one of the original 1854 ventilation towers, illustrating the importance that was heavily placed on the circulation of fresh air.

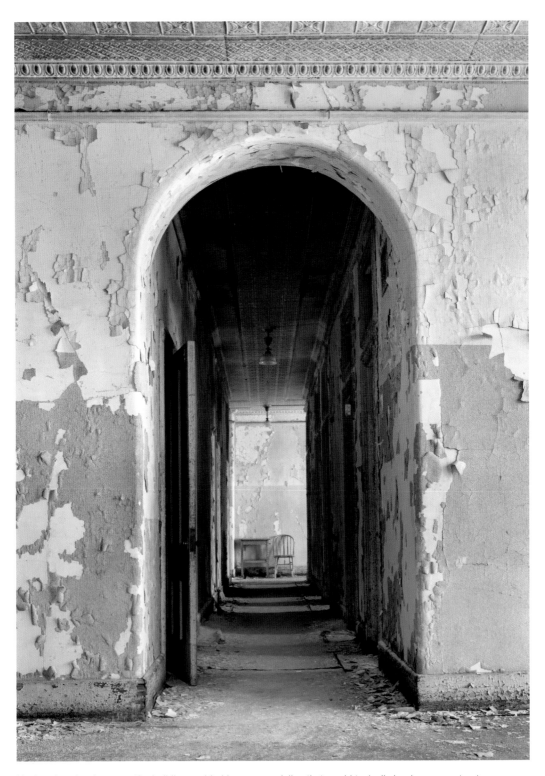

Having closed so long ago, the building avoided heavy remodeling that would typically be done on a structure of this age to bring it up to code. Many elements of the original architecture, such as the arched passages, wonderfully intricate tin ceilings and rounded plaster corners can be seen here.

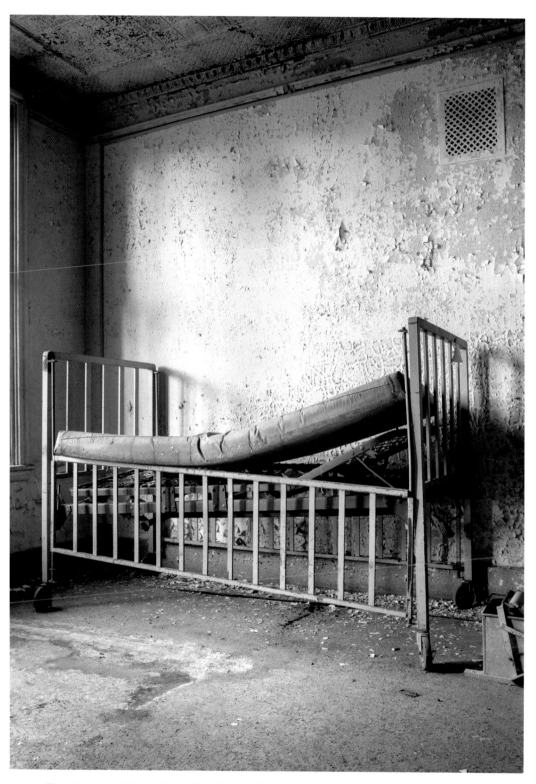

This crib-style bed featured side railings that could be raised to prevent someone from falling out when sleeping or recovering from coma-induced therapy.

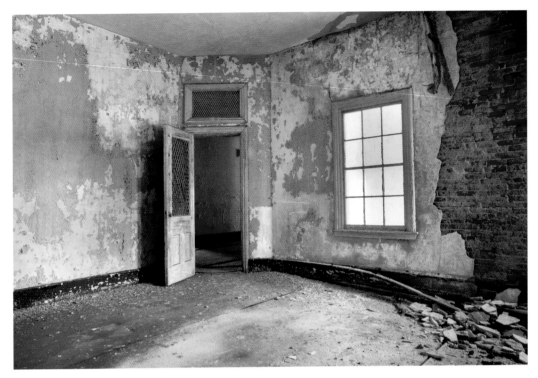

Attendant's rooms were located in the crux of the wings, with a partition that jutted out into the hallway for surveillance of the ward; these projections were later removed to allow more daylight into the hallways.

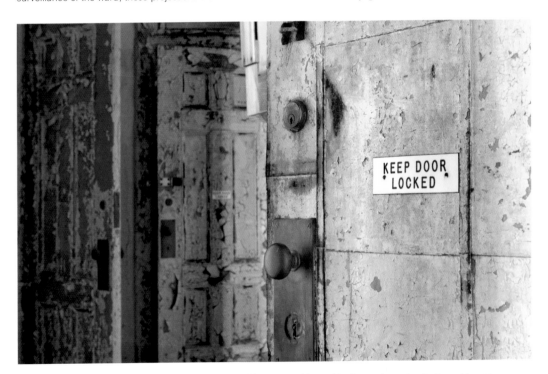

KEEP DOOR
LOCKED

Daily life at the state hospital revolved around locks and keys, as evidenced by these signs, deadbolts and hasps. The door in the foreground separated one ward from the other and was clad in steel to mitigate the spread of a fire.

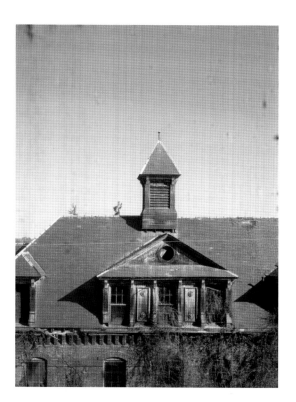

Just about every window at the hospital had been secured with heavy mesh screens, offering a hazy view of the outside world.

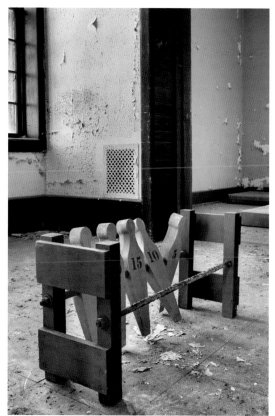

Amenities such as dancing, plays and movies were offered in the hospital's amusement hall, but simple games on the ward such as this one could easily brighten a person's day.

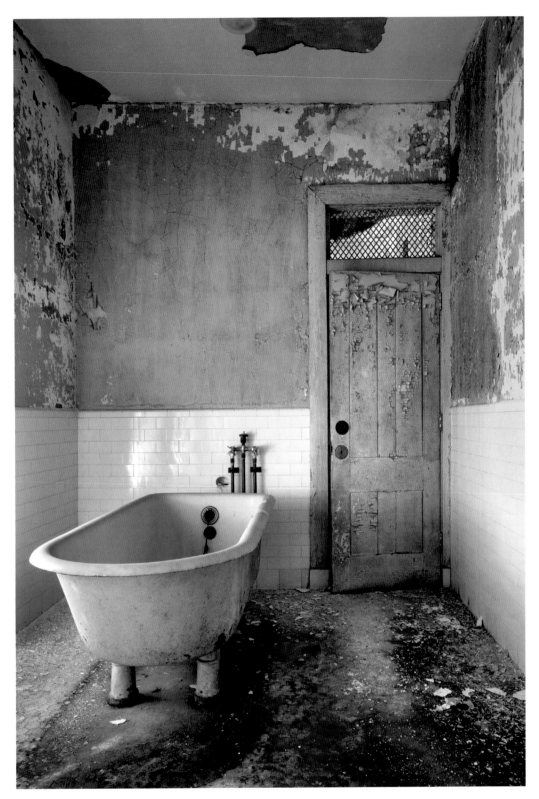

A small wash room on a ward.

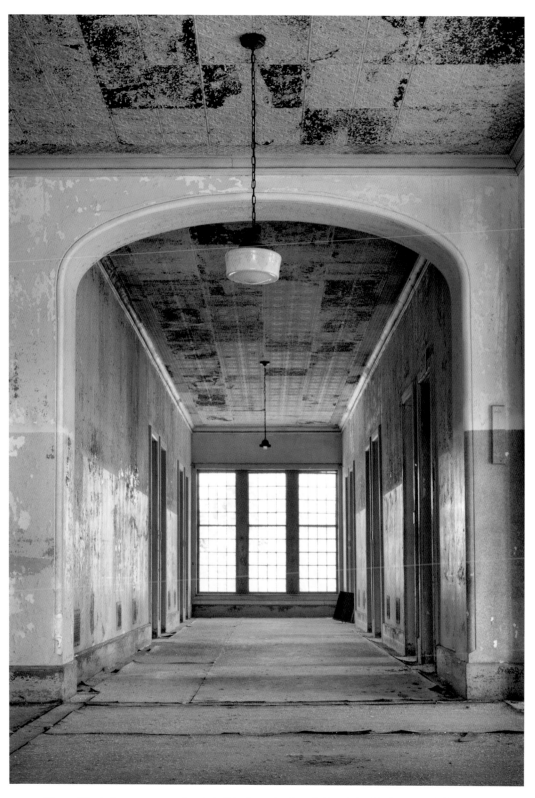

Many of the hallways were spectacularly lit by the natural sunlight entering the large, south-facing windows.

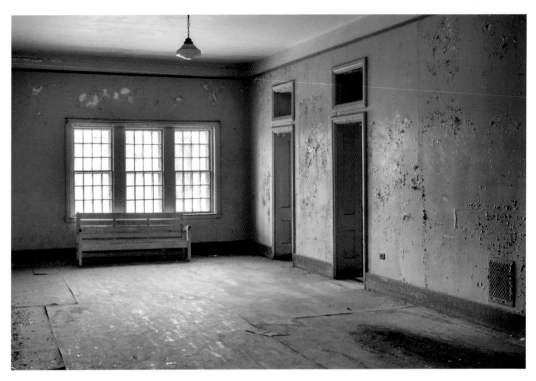

A ward on the third floor, which was used for the aged and infirm who would rarely leave the premises.

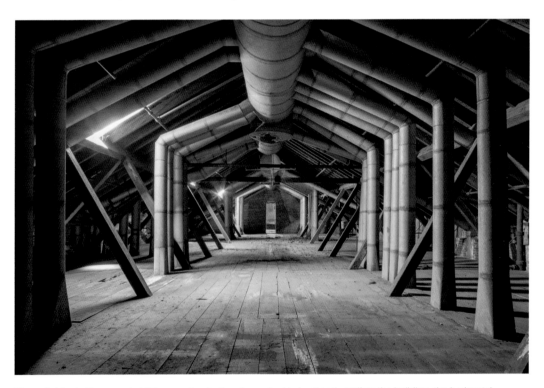

The unfinished attic space held the massive duct work required to heat and ventilate the building; the horizontal pipes terminated inside the ventilation towers.

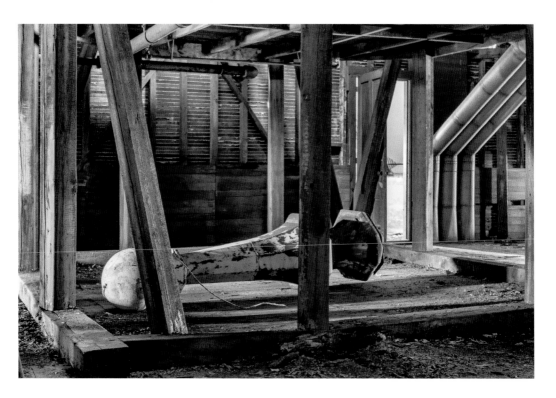

Above: In one of the attics, I discovered what appears to be the tip of the spire which once stood atop the original central dome.

Right: This room had held patient belongings, and the owners were identified using a bed number.

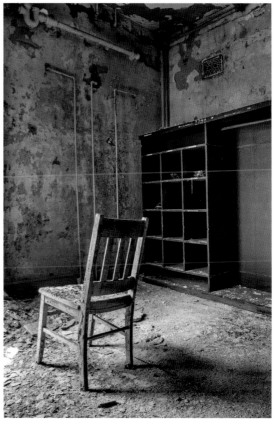

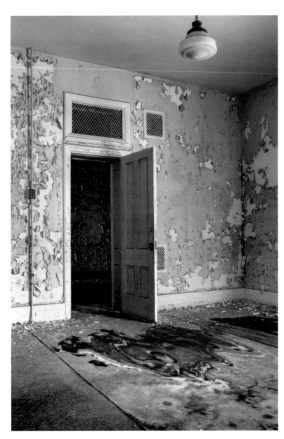

Left: A spilled paint can created intricate swirls of color on the floor of this room.

Below: Looking out towards the center of the complex from the female wing, where the administration block had been gutted by fire. On the right are various service buildings, such as the laundry and kitchen.

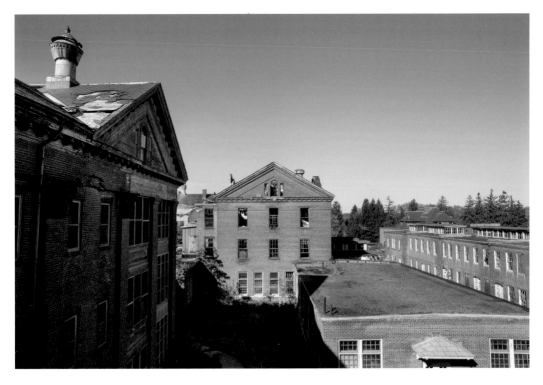

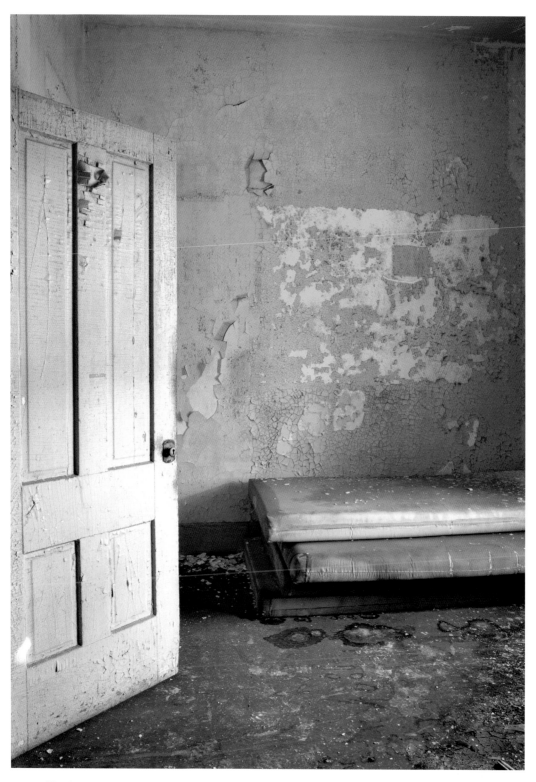

The doors retained their original hardware, and required a large, hefty key to open. The size of the keys helped staff easily unlock a door in the dark or in an emergency, and made stealing them more difficult.

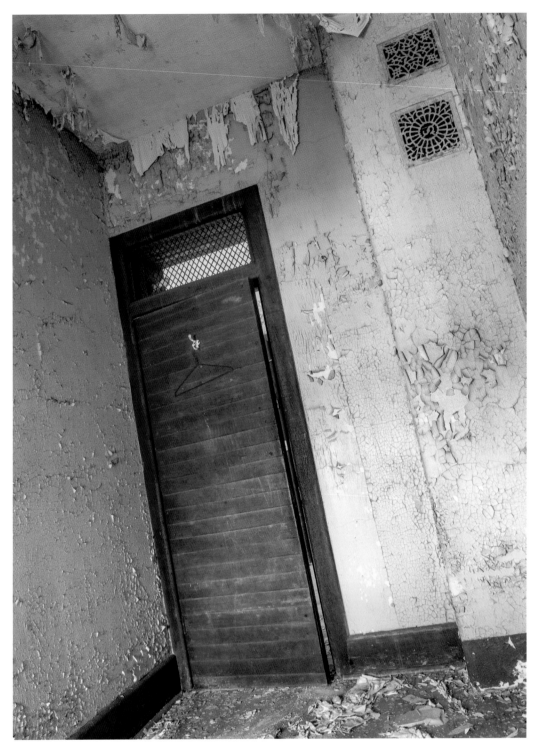

This heavily reinforced door may have originally been used for seclusion—a secure place where a violent patient could calm down. However, the coat hook and hangar hint at a less restrictive use during its later years of operation. A 1938 report notes that "no seclusion is employed, and the only type of restraint is an ordinary sheet with a clove hitch."[15]

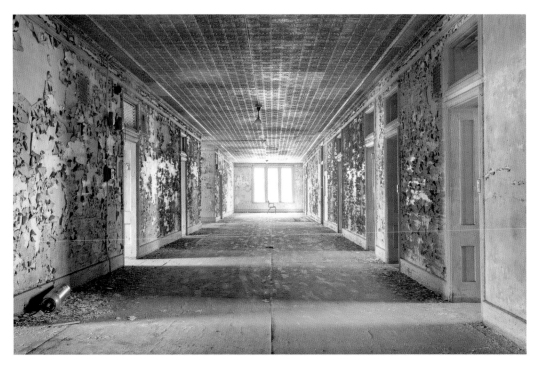

The breadth of the corridors in the original building was astoundingly large; Kirkbride had recommended a width of at least twelve feet in the wings and no less than fourteen in the center block.[16]

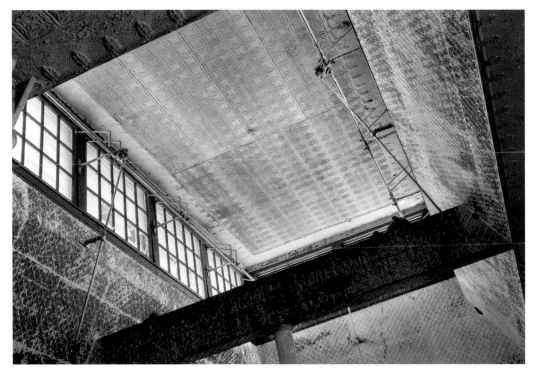

These skylights, located in a large day room, were fitted with armatures which were able to open the windows for additional ventilation.

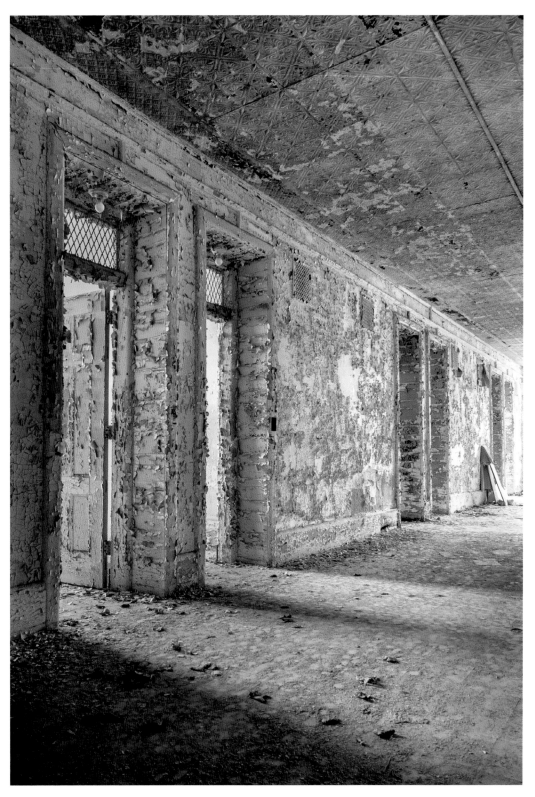

A layer of white paint peels back to reveal colorful schemes from earlier times.

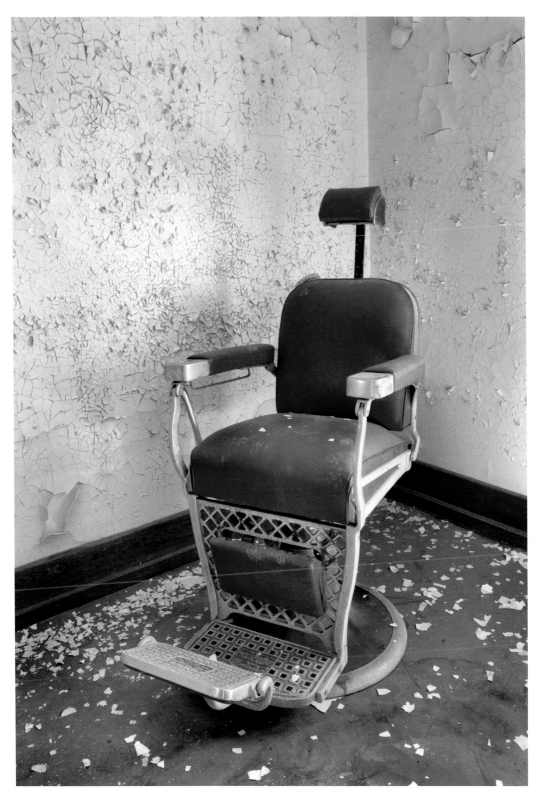

A barber's shop was located in the male department for haircuts and shaving.

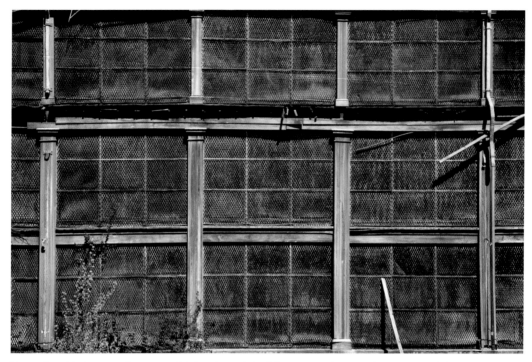

These dismal-looking porches were added to the main building around the turn of the century. Built to give patients fresh air and sunlight without having to leave the premises, their functionality was somewhat smothered by the oppressive steel grilles which created a rather gloomy atmosphere.

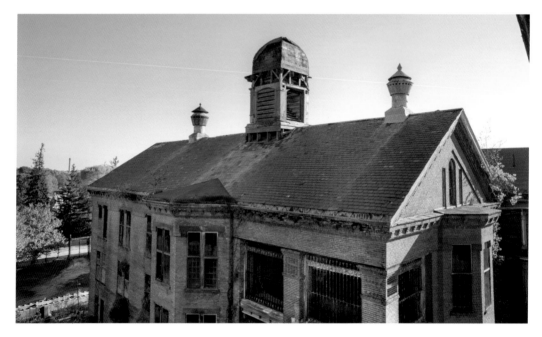

A view of the 1873 wing added to the Kirkbride building to alleviate overcrowding. The iron bars enclosing the verandas had decorative flourishes, but they emanated a zoo-like appearance. We can also see that the architect had done away with elaborate accents found on the original building, such as the sash windowed cupola, as well as the cast iron dentil work and capitals (although these have been represented with brick work).

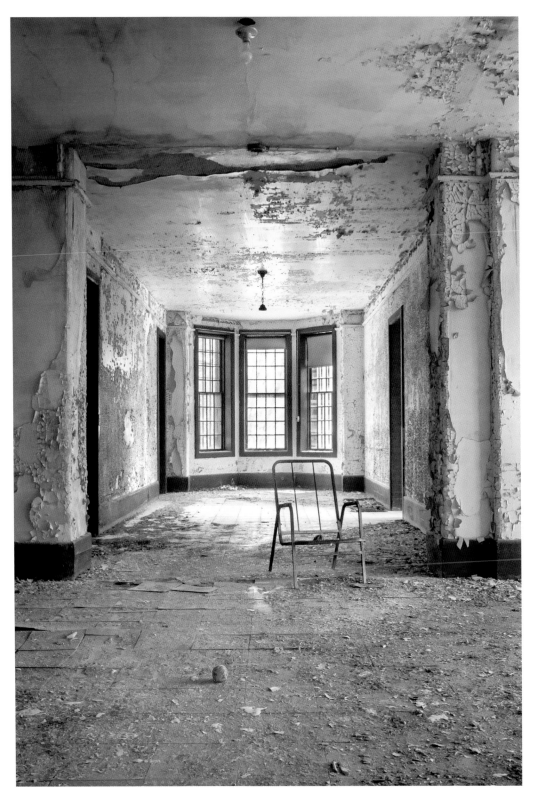

A ball of yarn blends into the detritus on the floor in a female ward.

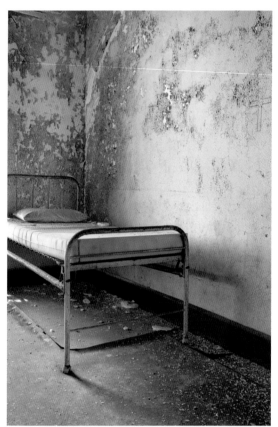

Left: The walls of patient rooms and common areas at Taunton were not scribbled on like many other hospitals I've photographed, but I noticed a neatly drawn crucifix in this room.

Below: A shower room on the ward, crammed with seats.

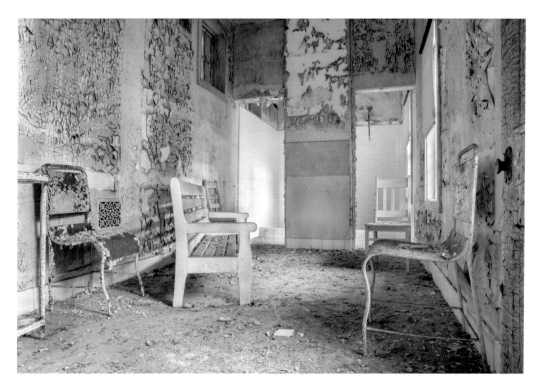

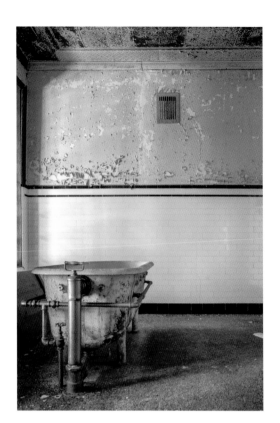

A continuous bath tub, used in hydrotherapy treatments where warm water was circulated around patients in an effort to soothe agitation. Hooks around the edge of the tub were used to secure a canvas sheet across the top, which limited their movement.

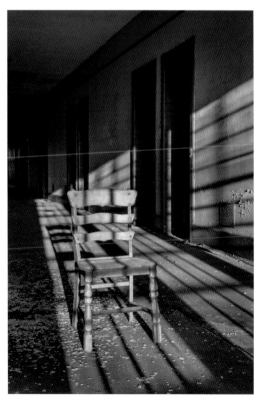

The rising sun shines in through the hospital's barred windows.

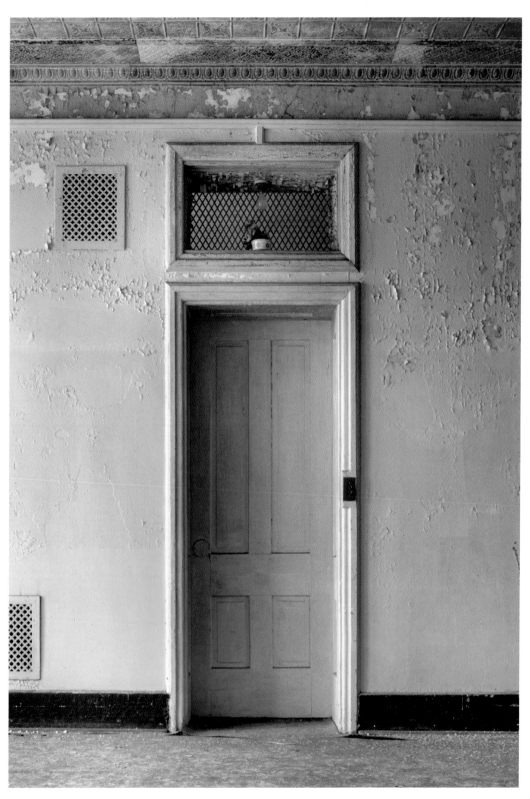

Transom openings above the doors assisted in heating and ventilation of the single bedrooms.

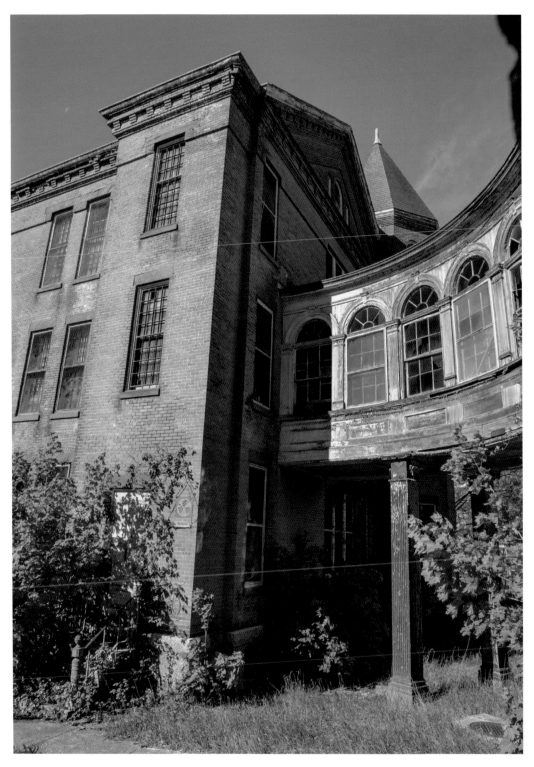

The men's infirmary, built in 1892. The stunning breezeway, made of brown ash and supported by steel columns, connected the infirmary wing to the Kirkbride complex on the second floor. This single-floor connection helped isolate the wing from the rest of the building, especially during an outbreak of disease.

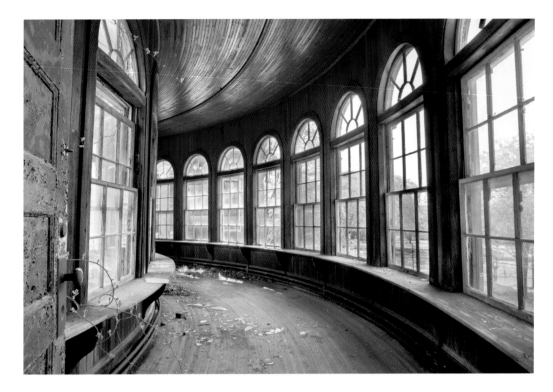

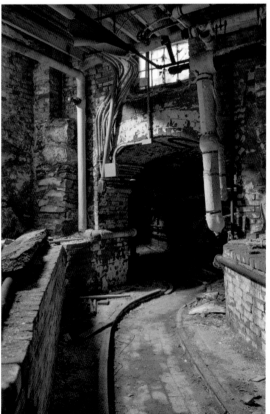

Above: The graceful curve of the breezeway is reminiscent of the connecting corridors at Buffalo State Hospital's Kirkbride building in New York, built in 1880. The shape of the connections at Buffalo discouraged the opportunity to use the space for beds, and the high visibility offered by the windows allowed surveillance of staff movements.[17]

Left: The basement of the Kirkbride structure meandered underneath the stepped wings and branched off in several places to form a connection to the powerhouse and service buildings. A track on the floor was used by laundry carts on wheels.

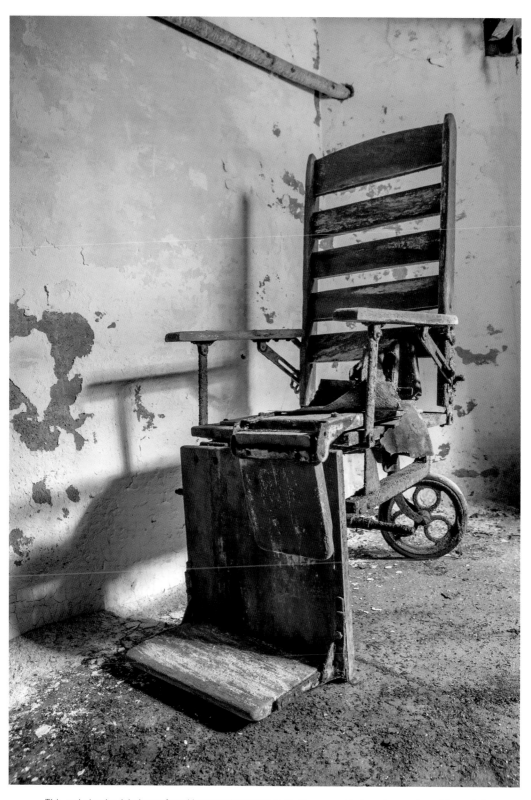

This archaic wheelchair was found in an underground room; it appeared to have been salvaged for parts long ago.

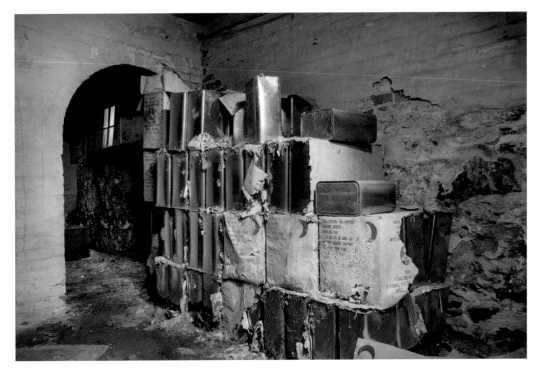

The fieldstone basements were sturdy and expansive enough to be used as fallout shelters in the event of a nuclear attack. The metal containers here are filled with "survival crackers," which were baked by the U.S. Government during the Cold War.

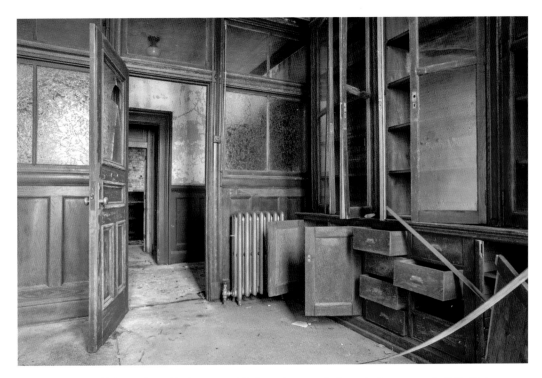

This unique space with its wooden cabinetry was most likely used as a medical examination room or dentist's office.

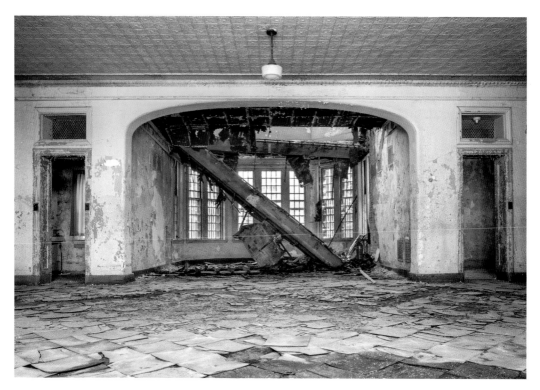

A collapsing parlor in the Kirkbride complex due to water intrusion. Despite this localized damage, the building seemed to be in pretty decent shape for being closed for over thirty years.

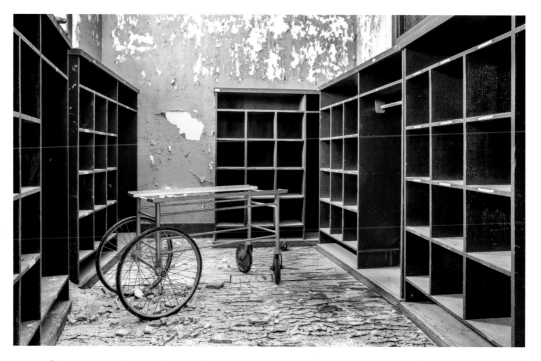

Storage rooms were used for supplies and to keep prohibited patient belongings off the ward, such as razor blades, lighters, and alcohol-containing perfume.

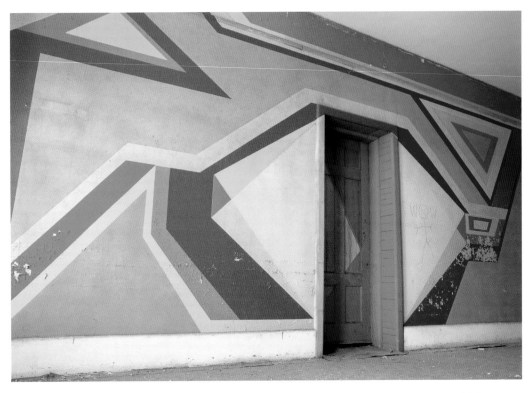

A few areas were decorated using a modern design, which likely took place just before the building closed in 1975.

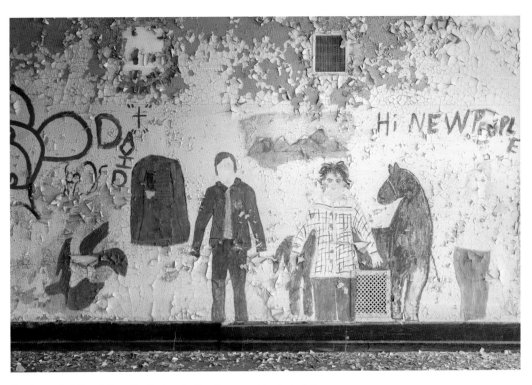

The figures in this painting, like the hospital itself, seemed to slowly fade away.

NORTHAMPTON STATE HOSPITAL—
HOSPITAL ON THE HILL

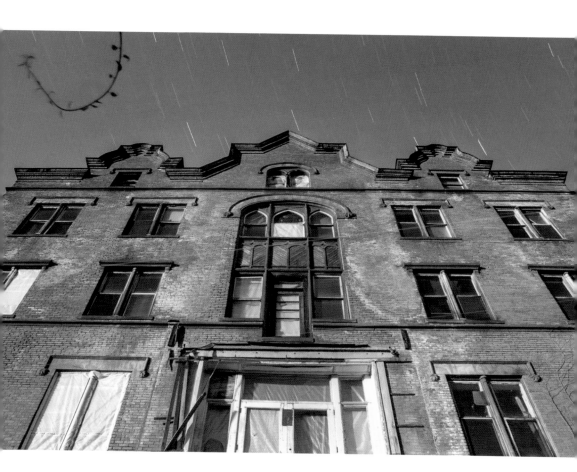

Northampton is a quaint town much like many the others dotting rural New England. Years ago, however, there was something quite extraordinary hidden behind a rusted fence smattered with "no trespassing" signs. Past the historic downtown and the manicured college campus, a once-majestic Kirkbride building was left to crumble. The cleanly swept streets and prim lawns of the homes nearby were a distant memory when stepping into its world of decay. The asylum seemed to reflect the minds of those who once lived here, as twisting corridors formed a disorienting labyrinth of rooms that stretched into impenetrable darkness. Its walls were covered in scars of methodic scribbles and beds were ominously bolted to the floor. Like the other venerable buildings restored in the town, its architecture was exquisite, but this edifice of unpleasant history was perhaps predestined for destruction.

Back on July 4, 1856, though, the hill was humming with activity. Not only was it a national holiday, but the groundbreaking ceremony for the Commonwealth's new state hospital had also begun.[1] Hope for curing the insane had finally arrived in the western portion of the state, lending the promise to unshackle those living in basements and receive proper medical care. A time capsule was placed in the cornerstone in remembrance of this day and construction began on a linear plan asylum based on Kirkbride's principles.

Architect Jonathan Preston (1801-1888) was appointed to design the building and his choice of a Jacobean-style design was rather unique for this time period.[2] His steep roof gables and stylistic parapets on the hospital formed a distinctive silhouette against the sky. The central administration block was flanked by the two linear plan wings; the southern side was strictly for female patients and the northern side was for men. The front entrance opened into a breathtaking rotunda that formed the central hub of the hospital. Twin elegantly curved staircases ascended on both sides leading to the rooftop dome, where superb views of the Connecticut Valley could be admired by staff and visitors.[3] Suicidal patients were placed next to the attendant's rooms, so they could be carefully observed at all hours. Areas near the main entrance were curiously designated as rooms "where patients see their friends;" such a thing would have been unimaginable just fifty years prior, when the mentally ill were shackled in irons. The building opened as The State Lunatic Hospital at Northampton on August 16, 1858, with 250 available beds.[4]

Although the hospital was built to serve the residents of western Massachusetts, transfers from the desperately overcrowded institutions around Boston flooded in. Within just six weeks of opening, the building was already at eighty-eight percent capacity. The stream of admissions were mostly chronic patients from the state asylums in Taunton and Worcester, which had quickly transformed the Northampton institution from a place of healing into a dumping ground of the state's worst cases

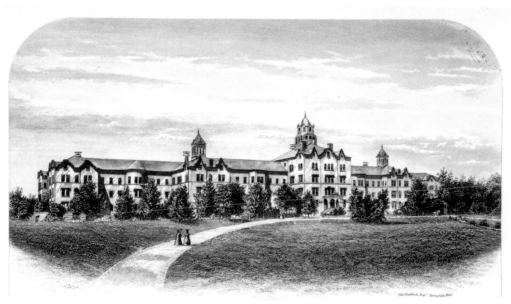

HOSPITAL FOR INSANE,
NORTHAMPTON, MASS.

This illustration shows the original hospital building and people enjoying the beautiful grounds. [Massachusetts State Archives]

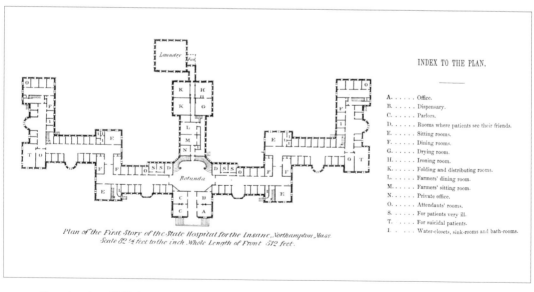

INDEX TO THE PLAN.

A. Office.
B. Dispensary.
C. Parlors.
D. Rooms where patients see their friends.
E. Sitting rooms.
F. Dining rooms.
G. Drying room.
H. Ironing room.
K. Folding and distributing rooms.
L. Farmers' dining room.
M. Farmers' sitting room.
N. Private office.
O. Attendants' rooms.
S. For patients very ill.
T. For suicidal patients.
I. Water-closets, sink-rooms and bath-rooms.

Plan of the First Story of the State Hospital for the Insane, Northampton, Mass.
Scale 82 ½ feet to the inch. Whole Length of Front 512 feet.

Floor plans from 1863 show adherence to Kirkbride's recommendations on the construction of asylums, such as the iconic crooked wings to separate individual wards and plenty of recreational space. [Massachusetts State Archives]

of insanity. The hospital's first superintendent had no training or experience in operating such an institution and quickly resigned. He was succeeded by Dr. Pliny Earle (1809-1892), a well-renowned physician and co-founder of the AMSAII. Earle became admired by both patients and staff at Northampton, and with his sharp eye for detail, a strong work ethic and a sense of frugality, he began to turn the institution's debt into a profit. By cutting unnecessary costs and expanding the hospital's farm, he had amassed over $440,000 in earnings for the asylum, which elated state officials and impressed superintendents at other state hospitals.[5] When he retired in 1886, he was given an apartment at the hospital in gratitude for his exceptional services, which had never been done before or since.[6]

Having been trained in the moral treatment philosophy, Earle was an ardent supporter of the linear plan and corresponded with Kirkbride often. His writings during his tenure at Northampton began to reflect a changing opinion however, as he saw uncured patients begin to accumulate in asylums across the country and his own institution. Those who were released would often return to be readmitted to the hospital; many superintendents would tout those initially released as cured and as a statistician, Earle recognized these highly inflated cure rates as false advertising. Even worse, this meant that the moral theory wasn't actually curing people. Although games of croquet and tranquil surroundings undoubtedly made life better for the patients, these efforts embraced by the Kirkbride plan were not freeing anyone from the torments of their psychoses. In one of his last publications in 1877, Earle had come to the stark realization that, "if insanity is to be diminished, it must be by prevention and not cure."[7]

As Earle watched Northampton shift from a place devoted to curing insanity into a facility which simply provided custodial care, he seemed to admit that the linear plan was not particularly well suited for this task. He began to consider that a smaller, detached system of buildings might be more effective, rather than elaborate Kirkbride plan hospitals that were being constructed *en masse* across the country. He purchased additional land at Northampton to give life to this idea; however, he found it to be too difficult of a task at his age to continue and the state's attention was instead focused on the extravagant asylums being built in Worcester and Danvers.[8]

Like other state hospitals at the turn of the century, Northampton was battling the ever-growing problem of overcrowding as beds were shoved into any available niche and hallway. Despite the hospital's powerful ventilation system, outbreaks of disease were impossible to avoid with such a dense population and two much-needed infirmaries were added to the building in 1903 and 1905 to help stop the spread of contagion. Similar to the infirmaries added to the asylum at Taunton, these structures were also appended onto the ends of the building (although they were not kept symmetrical).

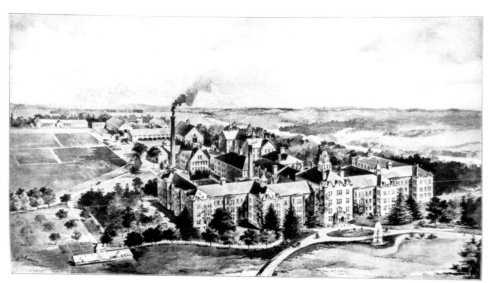

NORTHAMPTON LUNATIC HOSPITAL.

This illustration shows several early additions to the hospital such as a cast iron fountain (1876), the dormitory for male patients who worked the farm full time (1892) and a greenhouse. [Massachusetts State Archives]

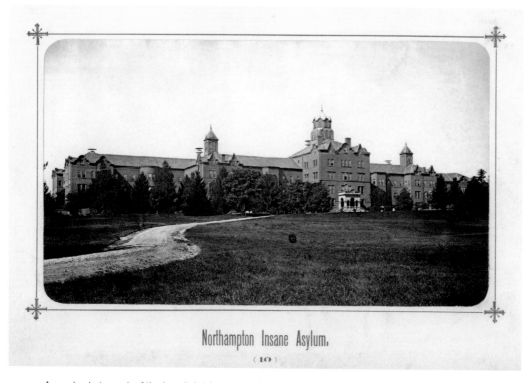

Northampton Insane Asylum.

(10)

An early photograph of the hospital, taken some time between 1876 and 1899. [Author's collection]

Most of the overcrowding stemmed from elderly chronic patients, who were generally considered "hopeless" and piled up in Northampton's wards to live the rest of their lives at the facility. To address this problem, a group of buildings called the Memorial Complex was erected in 1936, which would provide psychiatric care for the aged and infirm. The original Kirkbride building became affectionately known as "Old Main" in order to distinguish the two areas. Despite these major expansions, Northampton State Hospital would remain overburdened, underfinanced and was forced to resort to providing only the basic needs of its patients by the 1950s.

Treatments at Northampton included hydrotherapy, where continuous bath tubs would immerse patients in constantly flowing warm water for hours to induce a calming effect. For those still agitated, cold "wet packs" were administered, which consisted of wrapping the patient tightly in a cool wet sheet like a mummy and keeping them restrained in this way for a few hours; some of the most disturbed patients were re-packed and remained under the treatment for a month or more.[7] Although the process may sound sadistic, cold wet packs were life-saving measures for overexcited patients whose core body temperatures became critically high; the only other methods of control were rudimentary medications and the straitjacket, both of which only made the patient's temperature rise even more and could become fatal.[9]

Hydrotherapy was largely replaced by electroconvulsive therapy (E.C.T.) at Northampton. Inducing seizures using E.C.T., or "shock therapy," consisted of the physician operating a small device which sent an electrical current through the patient's brain between two electrodes placed on the head. While lasting only a second or so, the resulting spasms were often powerful enough to require several attendants to hold the patient down. New paralyzing drugs have since eliminated the violent muscle seizures, and although largely stigmatized, electroconvulsive therapy is still considered a viable method for treating depression, catatonia and other psychoses.[10]

Despite these treatments helping people live with severe disorders, they were sometimes used as punishment to negatively reinforce unwanted behavior. Other times there simply weren't enough people on staff to administer them. These years of custodial care during the middle of the twentieth century were incredibly difficult for both workers and residents. Staff interviews in J. Michael Moore's book *The Life and Death of Northampton State Hospital* describe how basic needs such as bedsheets and clothing became scarce, and even how some employees had to resort to making their own supplies.[11] Instead of treatment, safety became the top priority in order to protect everyone on the ward from harm, especially when there was only one staff member in charge of up to sixty disturbed patients at a time. Unfortunately, this meant that some particularly violent residents were kept locked in their rooms

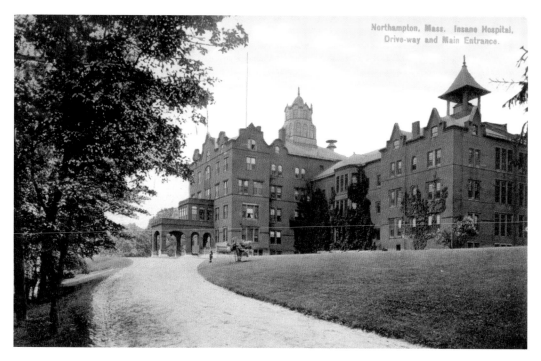

This 1910 postcard shows extensive renovations to the front of the building performed in 1899, which include a four-story addition and extending the porch to form a *porte-cochère* for horse-drawn carriages. New ventilation towers were also added for the forced air heating system. [Author's collection]

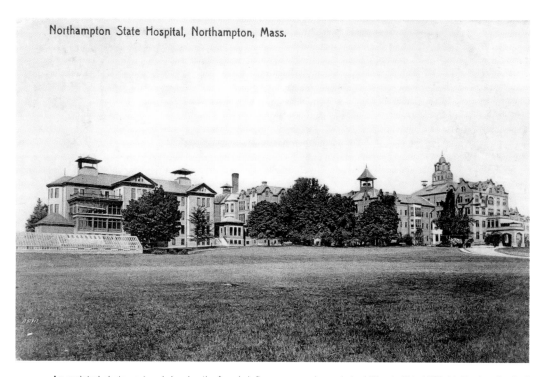

Northampton State Hospital, Northampton, Mass.

An undated photo postcard showing the female infirmary, a much needed addition built in 1903. [Author's collection]

for most of the time, or were strapped to beds and benches at the slightest sign of excitement to prevent dangerous situations.[12] Before the advent of non-addictive tranquilizers, however, there was little recourse for this underfunded institution.

Northampton State Hospital reached its peak population in 1955 with 2,877 patients crammed into every available space possible.[13] That year, Chlorpromazine (also known under its trade name, Thorazine) was first tested at Northampton on a handful of chronic patients and their remarkable improvement had impressed doctors.[14] With the power to calm the most agitated patients, Thorazine was used in every mental hospital across the country and was given to about 2 million people within the first year of its debut.[15] Those who were plagued by hallucinatory voices or irrational fears could now be treated outside the hospital with medication, and combined with legislation that pushed for community treatment, Northampton had finally began to see a decrease in their patient census.[16]

In 1978, a lawsuit filed against the state on behalf of patients mistreated at Northampton led to the passing of the Brewster Consent Decree.[17] It stipulated that the hospital must empty itself within two and a half years, but the process of placing hundreds of people back into nursing homes, group homes and elsewhere in the community proved to be a daunting task, taking fifteen years to accomplish.[18] This mass exodus slowly transformed the hospital from a bustling metropolis into a ghost town.

After 130 years of operation, Old Main was emptied and shuttered in 1986, as patients were moved to newer buildings on the campus. By August of 1993, the entire facility was closed as the last eleven patients were discharged.[19] Preservation efforts were largely ignored as the building was too costly for developers to remediate for profit, and Old Main fell into ruin as the town quarrelled for years over how to best redevelop the site.

Although the hospital had always been self-sufficient and rather secluded on the hilltop, it was not completely forgotten after its closure. In 2000, a notable series of memorialization events took place at the abandoned facility which included a symposium, art exhibitions and an open forum with former patients, headed by artist Anna Schuleit and Historic Northampton.[20] It was an opportunity for prior residents and staff to come to terms with the emotions and memories of working and living at the hospital—from struggling to make ends meet in an overburdened institution, to the shock of leaving a place with a strong sense of community.

Despite its place on the National Register of Historic Places and the efforts of local preservationists, demolition of the hospital commenced in 2006 under direction of MassDevelopment, a pseudo-public agency in charge of redevelopment of the site. Since the opening of Old Main in 1858, the area where it stood had long

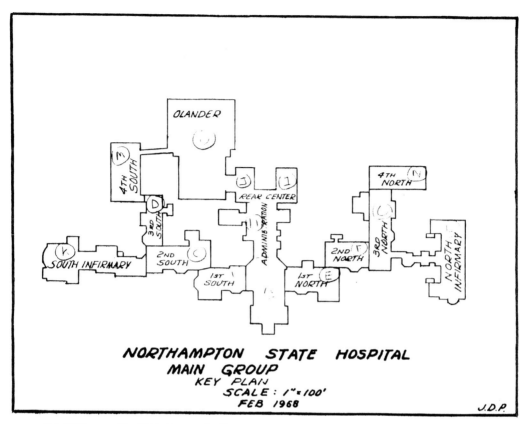

This 1968 map of the Kirkbride complex illustrates the many additions to the building's footprint over the years. [Historic Northampton]

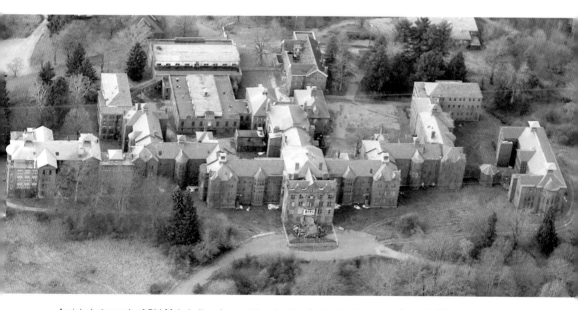

Aerial photograph of Old Main in its ruinous state, shortly after the front porch collapsed. [Pictometry/Bing Maps]

been known as Hospital Hill. The developers had originally designated the new mixed-use development as "Village at Hospital Hill," but it was ultimately changed to the innocuous "Village Hill Northampton," as it was thought it would be more attractive to prospective tenants.[21] At the time of this writing, there is no marker that hints of the storied institution that stood there for 162 years, designed to treat the community's most disadvantaged citizens.

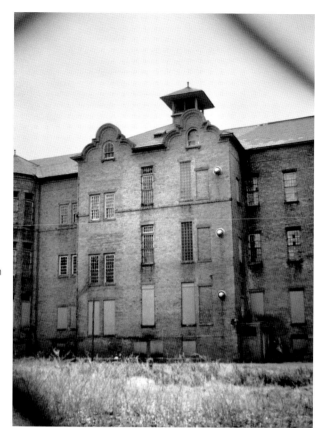

Right: A glimpse of the shuttered hospital behind the perimeter fence. The large ventilation towers were often mistakenly seen as guard towers, vilifying the institution's façade. [22]

Below: The male wing and administration block on an overcast summer night. This view reveals modifications such as the increased height of the ward windows and the newer bricks of the forward administration extension.

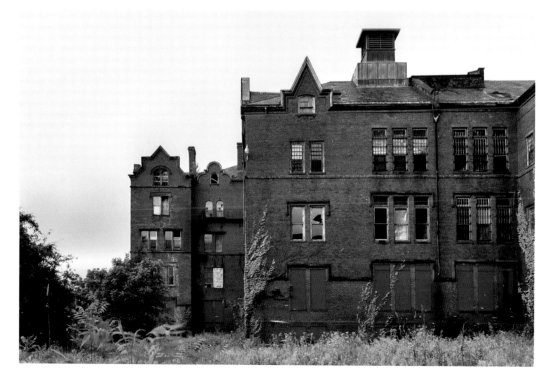

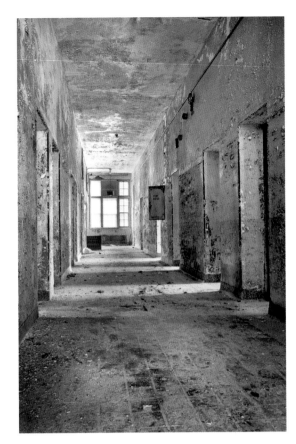

Left: A ward in Old Main after twenty years of abandonment.

Below: Interior view of a ward for men; the wide floor molding, added in later years, prevented wayward gurneys and wheelchairs from bumping into the walls.

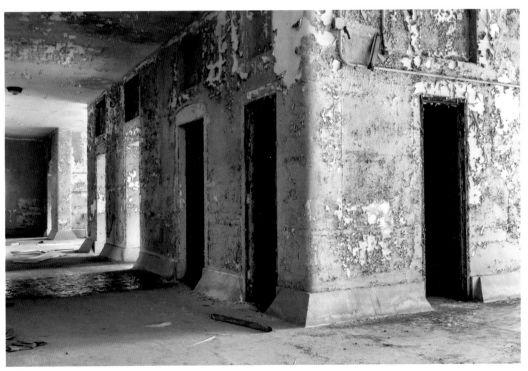

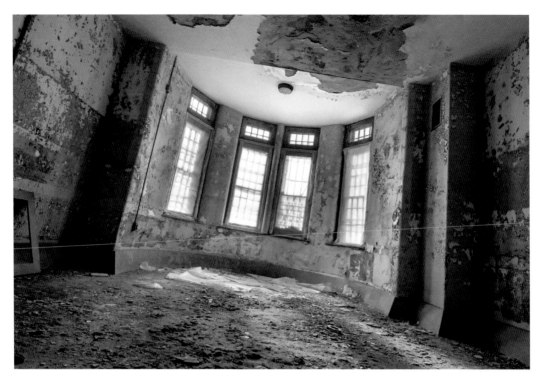

The curved turrets that projected from the building broke up the monotony of the rows of bedrooms and let sunlight into the corridors.

The walls of several rooms were laced with repetitive gouges in the plaster.

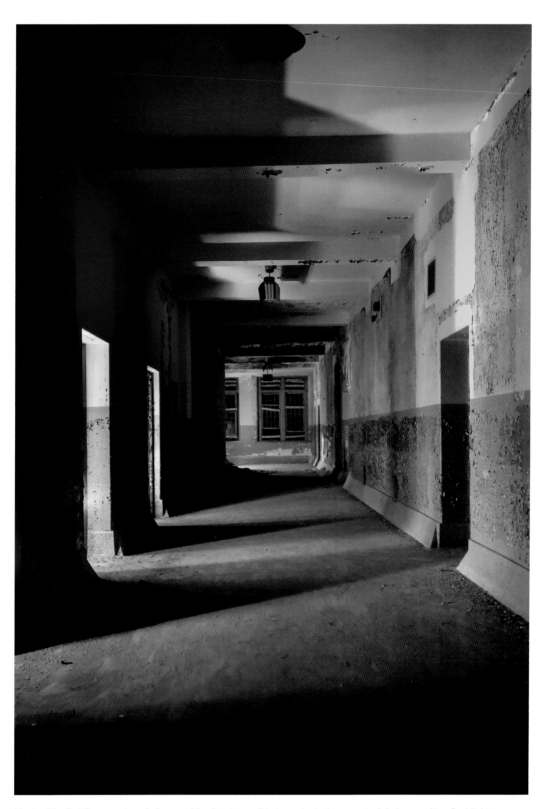

Much of the first floor was boarded up, making it only possible to navigate the perpetual darkness with a flashlight.

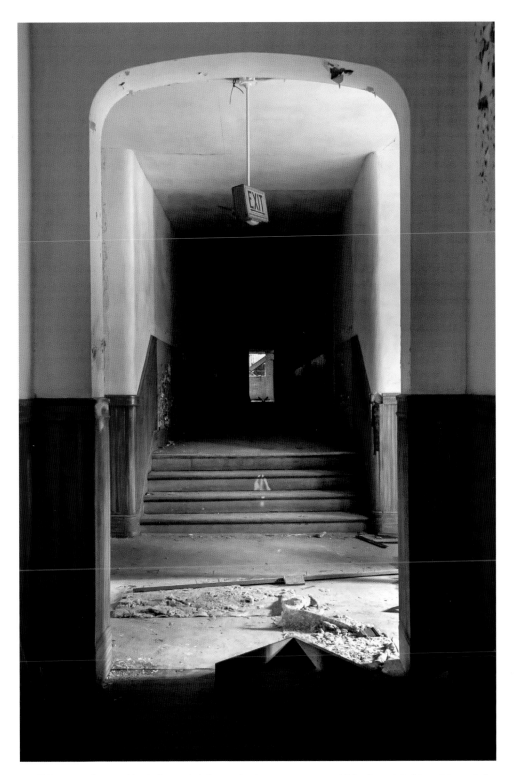

This connecting corridor to the male infirmary had a cross-passage which allowed staff to cut through the immense length of the Kirkbride building. The size and disorienting layout of Old Main could become a true maze in the darkness; various arrows were spray painted on walls by officials and explorers marking their way out.

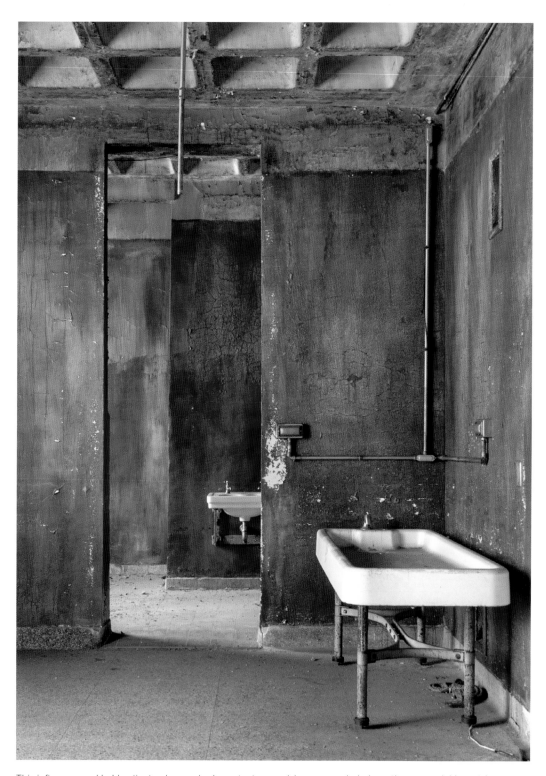

This infirmary ward held patients who required constant supervision—new admissions, those on suicide watch, patients recovering from shock therapy and those who were sick or frail.[23] The "slab tub" was used to bathe patients who had trouble getting in and out of a regular bath tub or too ill to leave the ward for a shower.

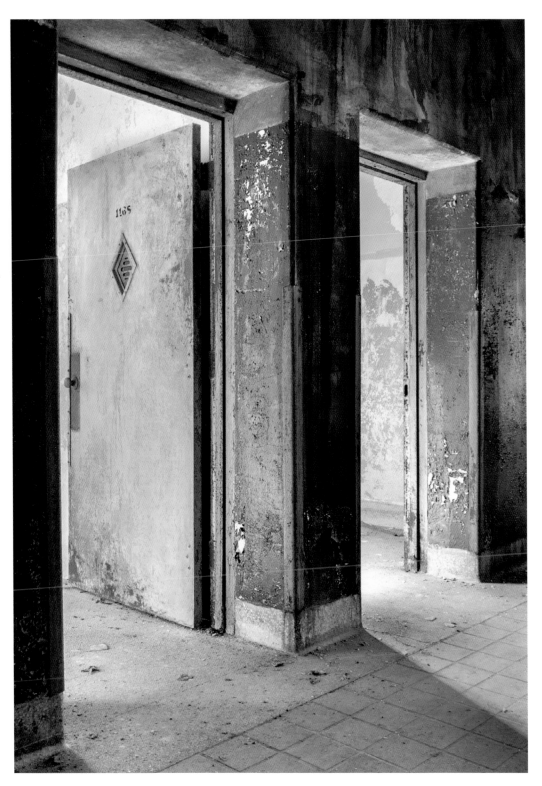

A locked ward for male patients prone to violent behaviour. The "wickets," or small windows in the doors, allowed staff to observe the condition of patients without disturbing them.

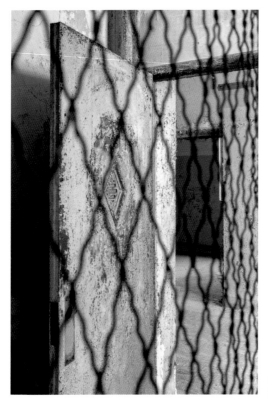

All stairwells were secured with wire mesh to prevent patients from jumping or falling off.

After twenty years of hanging on the back of a door, this handwritten note was faded beyond legibility.

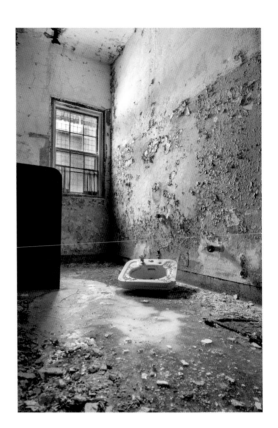

Small bathrooms such as this one contained only two toilets for forty-four patients during the times of overcrowding in the 1950s.[24] A bout of dysentery on the ward must have been unpleasant, to say the least.

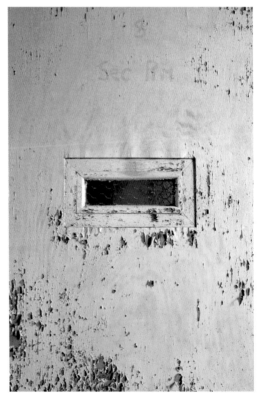

Single rooms in the ward for disturbed men were mostly used for seclusion, where a patient could be isolated from potentially hurting others during a violent episode.

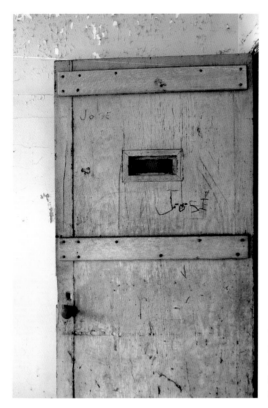

The splintered edge of this battered door was being held together with strips of wood. It speaks volumes about the hospital's desperate financial situation, as well as the violence that could be encountered here.

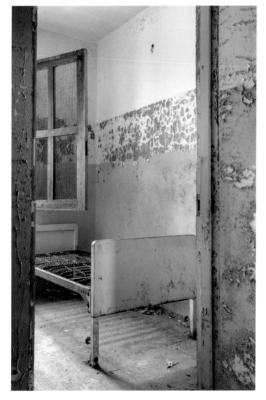

The bed in this seclusion room was bolted to the floor to prevent it from being moved or used as a weapon. Hooks on the insides of the legs provided tie down points for a canvas restraint blanket or cuffs.

Small decorations such as these flowers in a female ward were a reminder of the humanity of the staff, most of whom were trying to make the hospital a better place to live despite the conditions.

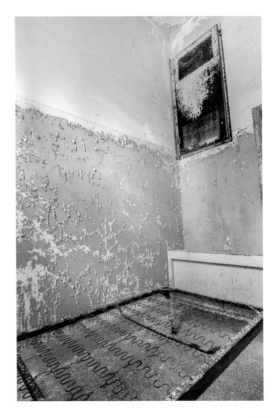

A seclusion room in a female ward. Fitting to the color scheme, the word "love" was faintly scrawled into the plaster wall next to the bed.

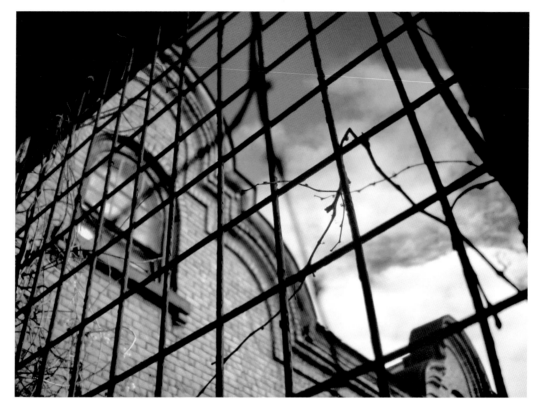

The heavily secured rooms and caged windows contrasted greatly with the elegant architecture of the Jacobean building.

An amazingly textured door to a treatment room. Although prefrontal lobotomy was quickly dismissed at Northampton, electroconvulsive therapy was administered extensively at the hospital.[25]

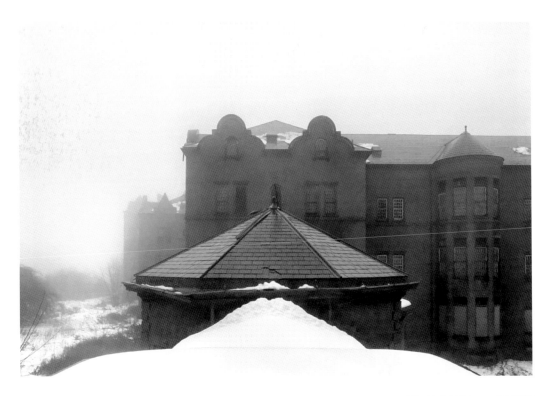

Above: A view of the original hospital building from the men's infirmary, during a snowstorm.

Right: Visiting the abandoned hospital at different seasons over the years led to many varied experiences, due to the weather that permeated the building. Here, frozen pools of water on the floor have begun to thaw, revealing my footprints.

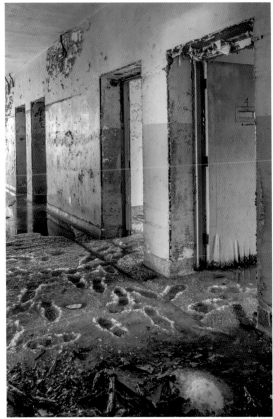

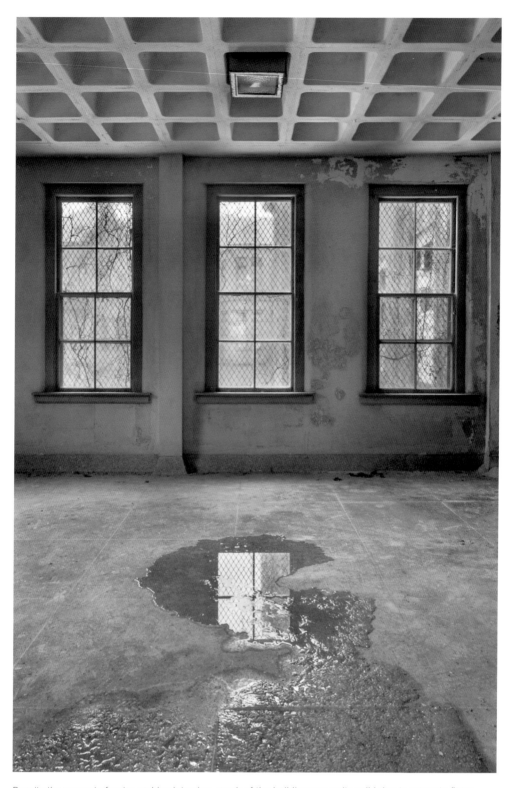

Despite the amount of water and ice intrusion, much of the building was quite solid due to concrete floors installed in the late 1950s.[26]

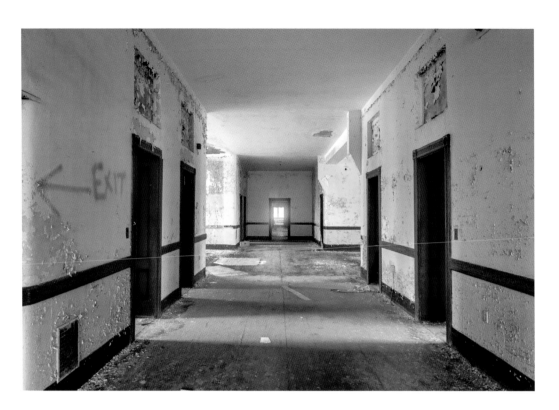

Above: The central portion of Old Main contained the superintendent's office, medical library, treasury, visiting rooms and other administrative areas. In the hospital's early years, the superintending physician and his family would live in apartments here to instill a sense of family at the institution.

Right: Curtains nailed to strips of rough lumber in this office juxtapose the otherwise opulent architecture of the building.

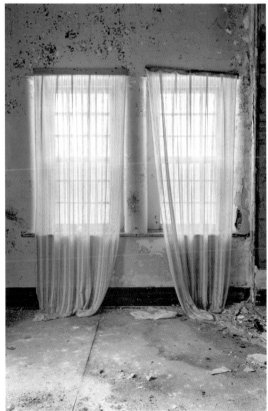

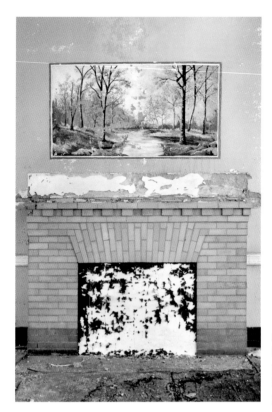

One of the many decorative fireplaces found in Old Main's administrative offices; they were probably blocked off to stop cold winter drafts in later years. The woodland scene above it was painted directly on the plaster wall.

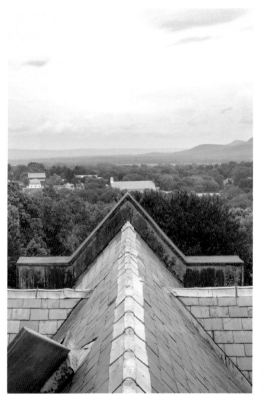

Looking out over the peaked roof of the institution towards Smith College, located adjacent to the hospital. Writer Sylvia Plath recalled hearing screams and howls emanating from the hospital when she studied at Smith in the 1950s.[27]

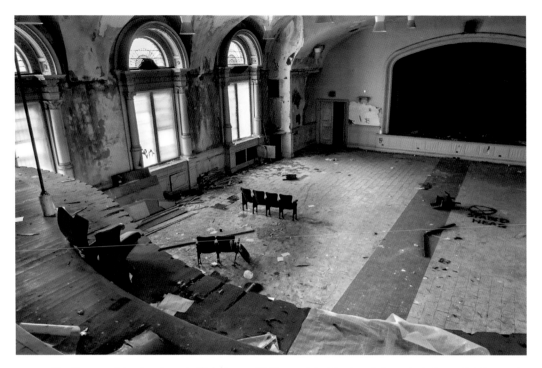

The Norman-style chapel was built during an 1895 remodel of the hospital's central wing, which featured a curved and suspended mezzanine, beautiful stained-glass windows and a pipe organ. The space was also used for many social events and a projector booth was installed on the mezzanine to show movies.

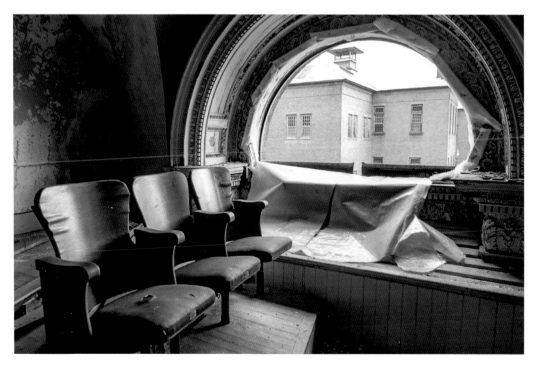

The stained glass in this window was likely salvaged after the building closed as it was easy to access, but this view shows the intricate craftsmanship of the decorative molding.

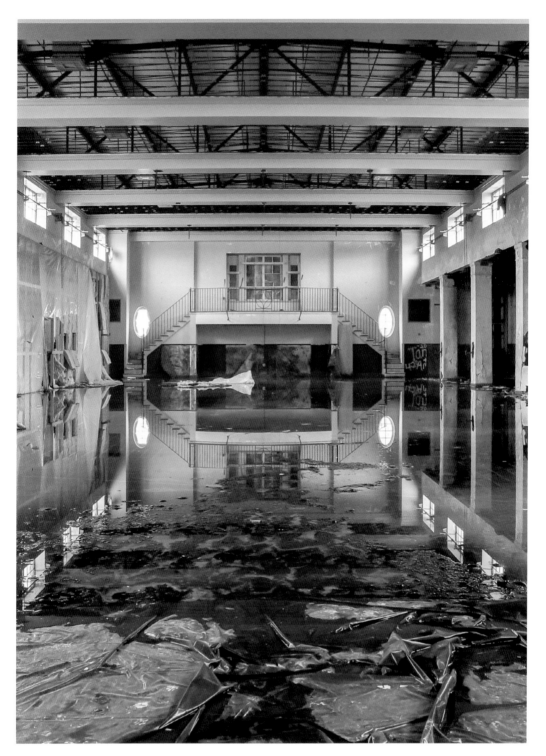

The Olander Cafeteria was built in 1938 with a capacity of 1,000 people and named after a Republican representative who secured the funding for the building during the Great Depression.[28] Prior to this, there were twenty-five small dining rooms throughout the building which proved wholly inadequate, especially when ward space was at a premium. The small balcony at the far end presumably allowed staff to surveil so many people at once.

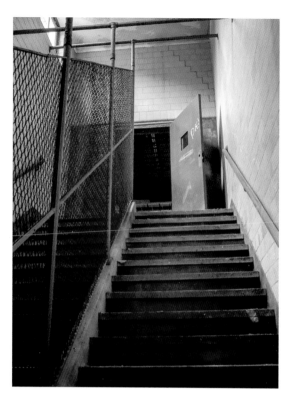

Right: Patients would usually be taken through underground tunnels to the cafeteria and other buildings on campus. Short-staffed attendants would have to move large throngs of people through these passages, and the fence along the center helped prevent violence or fraternization between two passing groups.

Below: This above-ground walkway was built to access the cafeteria from the female wards sometime after 1940—certainly an improvement from the dingy basements and steam tunnels. The ominous message "Stay Quiet!" can be seen in between the steps.

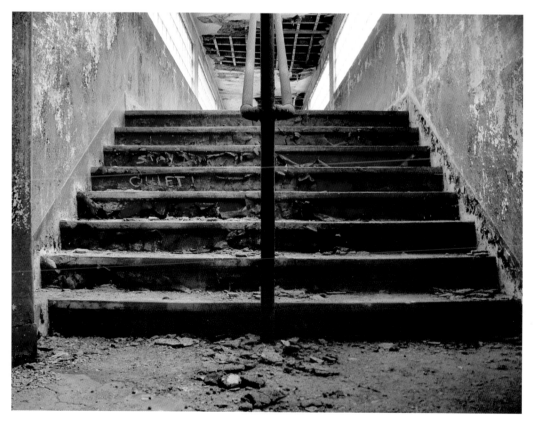

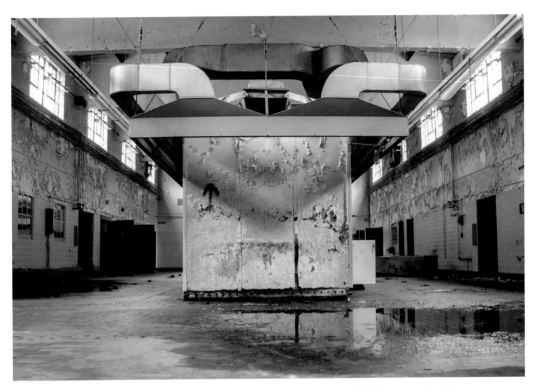

The main kitchen included a bakery, cannery and vegetable preparation room, all built to prepare healthy meals from the hospital's farm.

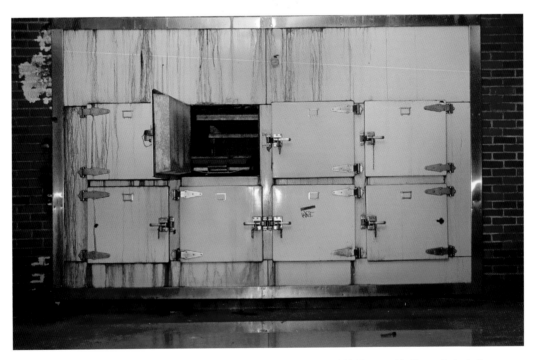

Located directly under the kitchen was the hospital's mortuary, also dating to 1938. Presumably, it was strategically placed to share the cooling system used by the kitchen's walk-in refrigerators, although this seemed a tad unsettling.

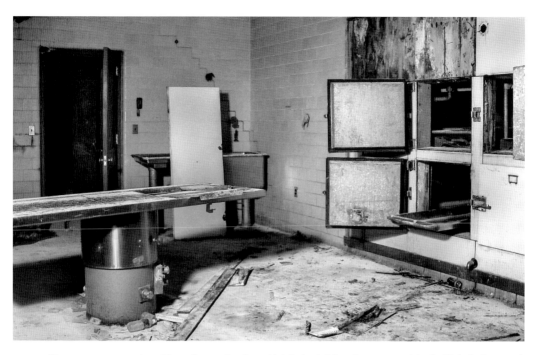

The morgue was equipped to perform autopsies, which helped determine causes of death. Biological research on causes of insanity and other ailments was also undertaken. If no family members were present to claim the body, the patient would be buried anonymously in the hospital cemetery.

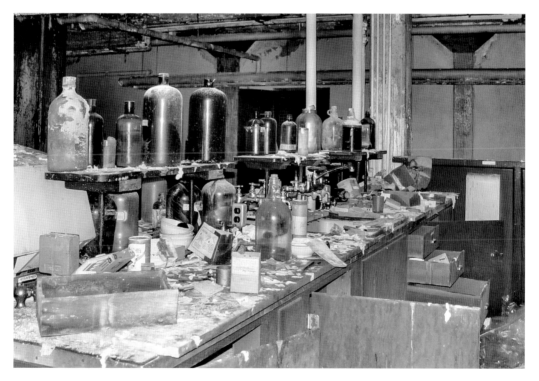

The pathological laboratory was still full of jars, chemicals and even tissue samples when I first visited the hospital, but it was mysteriously cleaned out shortly after.

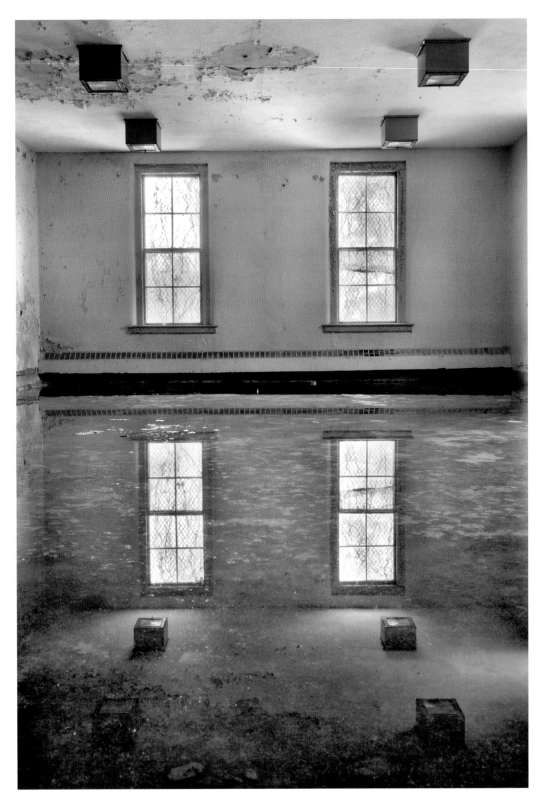

Reflections in the standing water beautifully mirrored the symmetry of this spartan room.

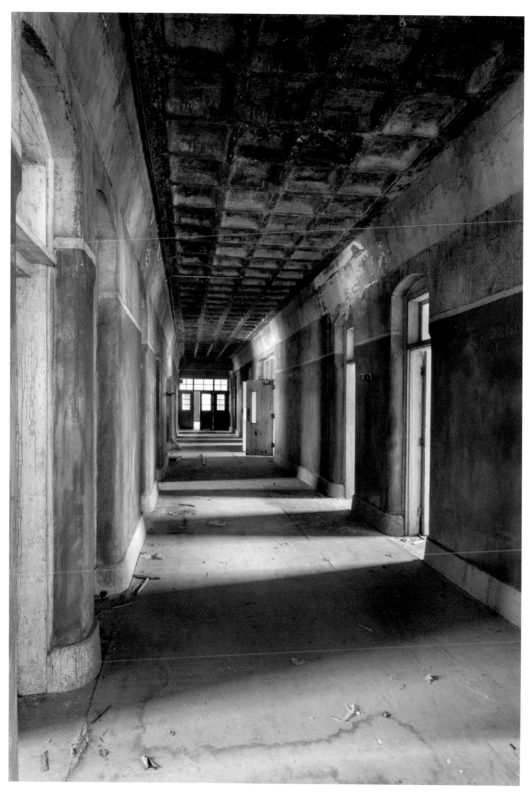

The soft diffused light of an overcast day created an incredible atmosphere in this infirmary hallway.

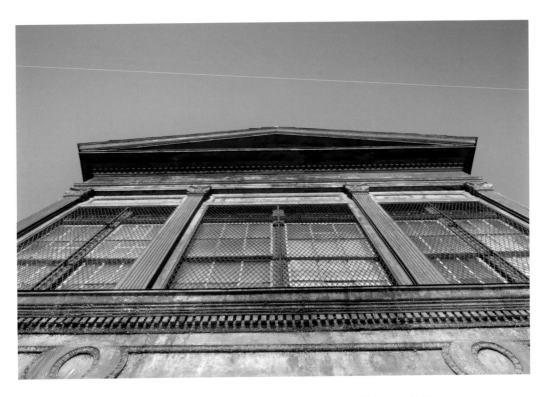

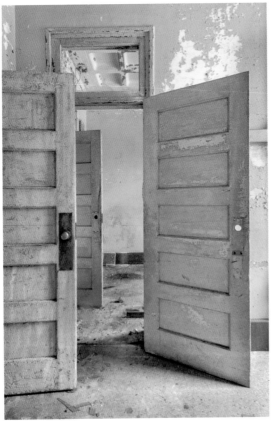

Above: Early additions to Old Main encompassed an elegance that matched the original building, such as the cast iron façade of the male infirmary, built in 1905.

Left: Certain rooms connected with others for reasons long forgotten.

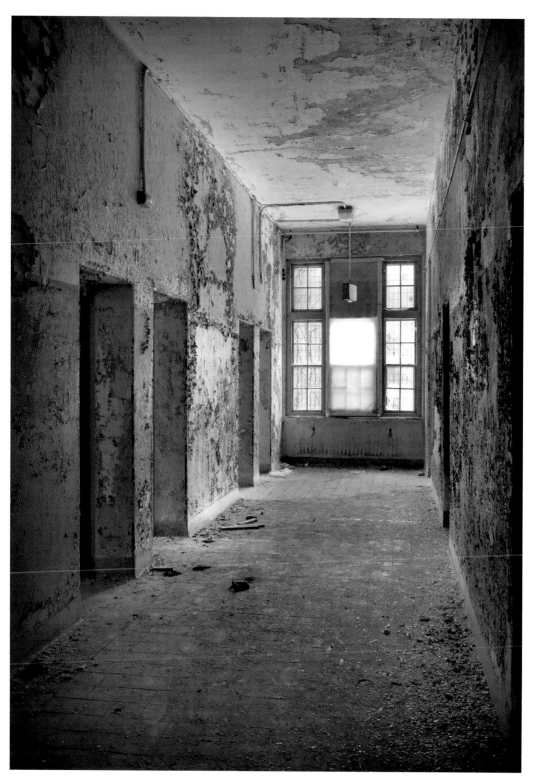

Built before electricity was available, the building was designed to let in maximum sunlight; however, later additions, which crowded around the original structure, made some wards incredibly gloomy.

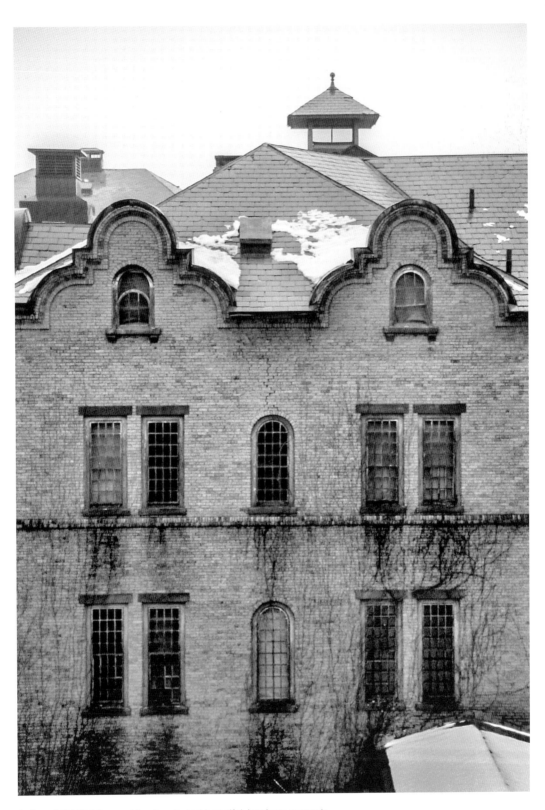

A view of Old Main's crumbling façade and beautiful Jacobean parapets.

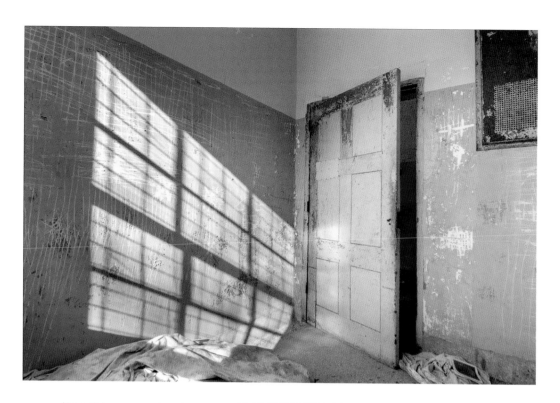

Above: This room may have been lived in after the building was condemned; state-operated programs helped place most people back into the community—however, some became homeless when the hospital downsized. Many patients, having lived here for so long, had become institutionalized and found life outside the hospital walls extremely difficult.

Right: A chair found in the hospital's pitch-black basement among spilled chemicals on the floor.

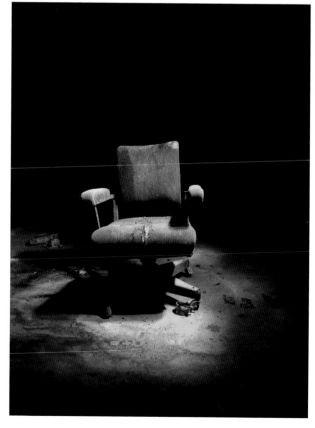

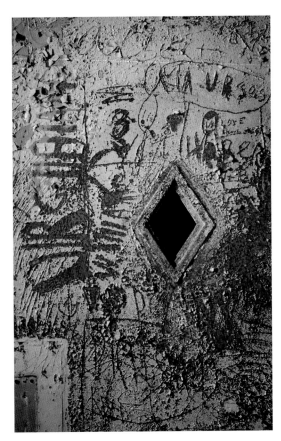

Left: Graffiti on the back of a steel door, found on the darkened first floor of the hospital.

Below: The hospital slowly disappears into its own shadows as a full moon sets below the hilltop.

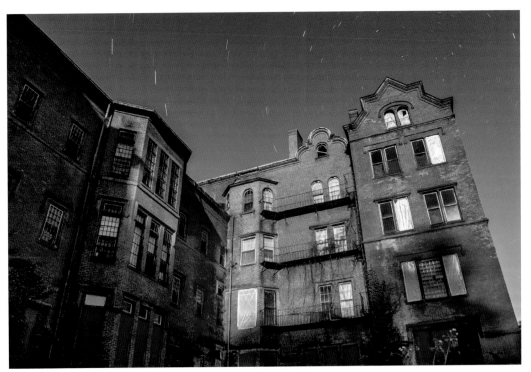

ENDNOTES

PREFACE

1 For an in-depth analysis of the decline of the state hospital system, see John A. Talbott's *Death of the Asylum: A Critical Study of State Hospital Management, Services and Care.*

INTRODUCTION

1 The first person to be admitted to a Massachusetts asylum was brought by his father, who thought he was possessed by the devil and whipped him incessantly. Folsom, *Diseases of the Mind*, 89.

2 Yanni, *The Architecture of Madness*, 42.

3 State Lunatic Hospital. *Report of the Trustees of State Lunatic Hospital, December 1833*, 22.

4 Dix, *Memorial, to the Legislature of Massachusetts*, 3-4.

TAUNTON STATE HOSPITAL

1 Taunton State Hospital, *Annual Report (1854)*, 3.

2 Ibid., 16.

3 Kirkbride, *On the Construction, Organization, and General Arrangements of Hospitals for the Insane*, 26-28.

4 Taunton State Hospital, *Annual Report (1854)*, 16-17.

5 The institution was subsequently known as Taunton Insane Hospital in 1898 and Taunton State Hospital in 1909.

6 Taunton State Hospital, *Annual Report (1873)*, 5, 38.

7 Taunton State Hospital, *Annual Report (1862)*, 30.

8 Richardson, "Captain Thomas Hubbard Sumner," 144.

9 Ibid.

10 *The Indianapolis Journal*, "Jane Toppan's Crimes," 5.

11 Potts, "Jane Toppan: A Greed, Power, and Lust Serial Killer."

12 Taunton State Hospital, *Annual Report (1952)*, 1, 3.

13 Taunton State Hospital, *Annual Report (1972-1973)*, 37.

14 Costello Dismantling Company, "Project Reference," 1.

15 Massachusetts, *Report of the special commission established to study the whole matter of the mentally diseased in their relation to the Commonwealth, including all phases of the Department of Mental Diseases, under Chapter 1 of the Resolves of 1938*, 290.

16 Kirkbride, *On the Construction, Organization, and General Arrangements of Hospitals for the Insane*, 15.

17 Yanni, *The Architecture of Madness*, 132, 137, offers this intriguing analysis of Buffalo's connecting corridors. It is uncertain if these factors contributed to their design at Taunton.

NORTHAMPTON STATE HOSPITAL

1 Haber & Moore, *Images of America: Northampton State Hospital*, 9.

2 The building was originally described as Elizabethan, a precursor to the Jacobean style. Massachusetts Historical Commission, *Form 1A*, 2.

3 The rotunda and dome were removed and floored over in 1958-1959 on all three floors and the additional space served as visiting rooms for the north and south wards. Haber & Moore, *Images of America: Northampton State Hospital*, 19.

4 The name of the hospital was changed to the Northampton Insane Hospital in 1899 and Northampton State Hospital in 1905.

5 Sanborn, *Memoirs of Pliny Earle, M.D.*, 263.

6 McGovern, "The Early Career of Pliny Earle: A Founder of American Psychiatry," 8.

7 Earle, *The Curability of Insanity: A Series of Studies*, 190.

8 Sanborn, *Memoirs of Pliny Earle, M.D.*, 275-276.

9 Callaway, *Asylum: A Mid-century Madhouse and its Lessons about Our Mentally Ill Today*, 75-76.

10 Ibid., 28-29.

11 Moore, *The Life and Death of Northampton State Hospital*, 19.

12 Ibid., 20.

13 Northampton State Hospital, *Annual Report (1955)*, 5.

14 Haber & Moore, *Images of America: Northampton State Hospital*, 83.

15 El-Hai, *The Lobotomist*, 253.

16 Lammers & Verhey, *On Moral Medicine*, 847.

17 Emery, "The Rise and Fall of State Hospital."

18 Ibid.

19 Ibid.

20 Haber & Moore, *Images of America: Northampton State Hospital*, 113-121.

21 Contrada, *Northampton State Hospital Artifacts Up for Bid*.

22 Haber & Moore, *Images of America: Northampton State Hospital*, 35.

23 Ibid., 77.

24 Ibid.

25 Moore, *The Life and Death of Northampton State Hospital*, 23.

26 Completed in 1960 at a cost in excess of $250,000, the fireproofing was lamented by the superintendent as unsatisfactory and that it was "advisable … to replace the remaining one hundred year old building with new buildings rather than fireproof them." Massachusetts Historical Commission, *Form 1K*, 2.

27 As quoted in a 1952 letter written by Plath. Haber & Moore, *Images of America: Northampton State Hospital*, 84.

28 Ed Olander Jr, March 17, 2012, 2:31pm.

BIBLIOGRAPHY

Billings, John S. and Henry M. Hurd. *Suggestions to Hospital and Asylum Visitors*. Philadelphia, PA: J.B. Lippincott, 1895.

Bucknill, John C. *Notes on Asylums for the Insane in America*. London: J. & A. Churchill, 1876.

Callaway, Enoch. *Asylum: A Mid-century Madhouse and its Lessons about Our Mentally Ill Today*. Westport, CT: Praeger Publishers, 2007.

Contrada, Fred. "Northampton State Hospital Artifacts Up for Bid." MassLive, June 2013. Accessed June 12, 2018. www.masslive.com/news/index.ssf/2013/06/northampton_state_hospital_art.

Dix, Dorothea. *Memorial, to the Legislature of Massachusetts*. Boston, MA: Munroe & Francis, 1843.

Earle, Pliny. *The Curability of Insanity*. Utica, NY: Ellis H. Roberts & Co., printers, 1877.

Ed Olander Jr, March 17, 2012, 2:31pm. "Comment on" Tom Kirsch, "Olander Cafeteria – Northampton State Hospital," opacity.us, August 1, 2004, https://opacity.us/image697_olander_cafeteria. htm#comment_156840.

El-Hai, Jack. *The Lobotomist: A Maverick Medical Genius and His Tragic Quest to Rid the World of Mental Illness*. Hoboken, NJ: John Wiley & Sons, 2007.

Emery, Theo. "The Rise and Fall of State Hospital." *Daily Hampshire Gazette*. Accessed July 7, 2018. www.cs.cmu.edu/~waisel/pomeroy/The%20rise%20and%20fall%20of%20state%20hospital.

Folsom, Charles F. *Diseases of the Mind*. Boston, MA: A. Wright, State Printer, 1877.

Historic American Buildings Survey, Creator, and Elbridge Boyden. *Taunton State Hospital, Danforth Street, Taunton, Bristol County, MA*. Bristol County Massachusetts Taunton, 1933. Documentation Compiled After. Photograph. www.loc.gov/item/ma1354.

Historic Northampton. "Northampton State Hospital Main Group." PDF file. February, 1968. Accessed June 18, 2018. www.historic-northampton.org/members_only/NSH/1map.pdf.

The Indianapolis Journal. "Jane Toppan's Crimes." *Hoosier State Chronicles.* June 25, 1902.

Jarvis, Edward. *Insanity and Insane Asylums.* Louisville, KY: Prentice & Weissinger, 1841.

Kane, Corey. "Taunton State Hospital closure opens debate over mental health care." *Taunton Daily Gazette.* June 11, 2012. Accessed July 8, 2018. www.tauntongazette.com/x2067832908/ Taunton-State-Hospital-closure-opens-debate-over-mental-health-care.

Kirkbride, Thomas S. *On the Construction, Organization, and General Arrangements of Hospitals for the Insane.* Philadelphia, PA: Lindsay & Blakiston, 1854 (1st ed.) and J.B. Lippincott & Co., 1880 (2nd ed.).

Lammers, Stephen E. and Allen Verhey, eds. *On Moral Medicine: Theological Perspectives in Medical Ethics.* Grand Rapids, MI: William. B. Eerdmans Publishing, 1998.

Mann, H., Bezaleel Taft Jr., W. B. Calhoun, et al. *Reports And Other Documents Relating To The State Lunatic Hospital At Worcester, Mass.* Boston, MA: Dutton and Wentworth, 1833.

Massachusetts Special Commission on Mental Diseases. *Report of the special commission established to study the whole matter of the mentally diseased in their relation to the Commonwealth, including all phases of the Department of Mental Diseases, under Chapter 1 of the Resolves of 1938.* Boston, MA: Wright & Potter Printing Co., 1939.

Mcgovern, Constance M. "The Early Career of Pliny Earle: A Founder of American Psychiatry." *Masters Theses 1911*, University of Massachusetts Amherst (May, 1971).

Massachusetts Historical Commission. *Forms 1-A through 1-O, Area Surveys.* Boston, MA.

The Miriam and Ira D. Wallach Division of Art, Prints and Photographs: Photography Collection, The New York Public Library. "State Hospital." New York Public Library Digital Collections. Accessed March 2, 2018. https://digitalcollections.nypl.org/items/510d47e0-7de2-a3d9-e040-e00a18064a99.

Moore, J. Michael and Anna Schuleit Haber, *Images of America: Northampton State Hospital.* Charleston, SC: Arcadia Publishing, 2014.

Moore, J. Michael. *The Life and Death of Northampton State Hospital.* Northampton, MA: Historic Northampton, 1994.

New York State. *Testimony taken by the Special Committee Appointed to Investigate the Affairs and Management of the State Lunatic Asylum at Utica.* Albany, NY: Weed, Parsons & Co., 1884

Northampton State Hospital. *Annual Reports (1858-1955).*

Sanborn, Franklin. B. *Memoirs of Pliny Earle, M.D.: With Extracts from His Diary and Letters (1830-1892) and Selections from His Professional Writings (1839-1891).* Boston, MA: Damrell & Upham, 1898.

Schneekloth, Lynda H., Marcia F. Feuerstein, and Barbara A. Campagna, eds. *Changing Places: Remaking Institutional Buildings.* Fredonia, NY: White Pine Press, 1992.

Scull, Andrew. *Madhouse: A Tragic Tale of Megalomania and Modern Medicine.* Yale University Press, 2005.

Skrabanek, Petr. "Convulsive Therapy – A Critical Appraisal of its Origins and Value." *Irish Medical Journal*, June 1986 v. 79, No. 6.

State Lunatic Hospital. *Report of the Trustees of State Lunatic Hospital, December 1833.* Boston, MA: Dutton and Wentworth, 1834.

Talbott, John A. *Death of the Asylum: A Critical Study of State Hospital Management, Services and Care*. New York, NY: Grune & Stratton, 1978.

Taunton State Hospital. *Annual Reports (1854-1973)*.

"Taunton State Hospital." Asylum Projects. Accessed March 3, 2018. www.asylumprojects.org/index. php/Taunton_State_Hospital.

Wyman, Morrill. *The early history of the McLean Asylum for the Insane: a criticism of the report of the Massachusetts State Board of Health for 1877*. Cambridge, MA: Riverside Press, 1877.

Yanni, Carla. *The Architecture of Madness: Insane Asylums in the United States*. Minneapolis, MN: University of Minnesota Press, 2007